NATURE IN
WATERCOLOUR

*Expressive painting
through the seasons*

*Expressive painting
through the seasons*

NATURE IN
WATERCOLOUR

Waltraud Nawratil

SEARCH PRESS

Contents

03 Spring

04 Summer

05 Autumn

06 Winter

Opening reflections

I feel that my engagement with nature forms the basis of my painting. Going through life with my eyes open (in the truest sense of the word), memorizing, recording and archiving what I have seen – no matter in what form – is the inspiration for my work.

And it doesn't matter whether the captured moments were when the sun was shining, or when I was standing under an overhanging roof during a storm with thunder, lightning and heavy rain coming down, or whether I was in a cold mountain hut or luxuriating in a warm room with a tiled stove, sipping my afternoon tea.

Watercolour painting cast its spell on me more than 26 years ago. Using water and paints, I can paint the diversity and beauty of nature on a sheet of paper and bring that sheet to life. I want to bring happiness to the viewer's heart when they look at my paintings – to freely quote the words of one of my daughters.

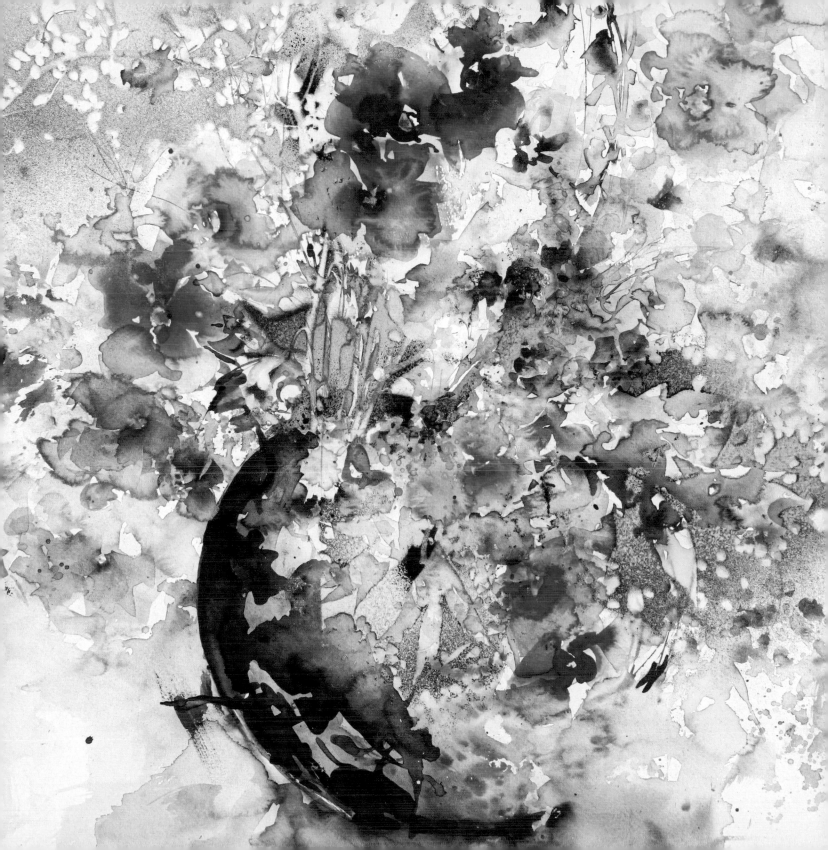

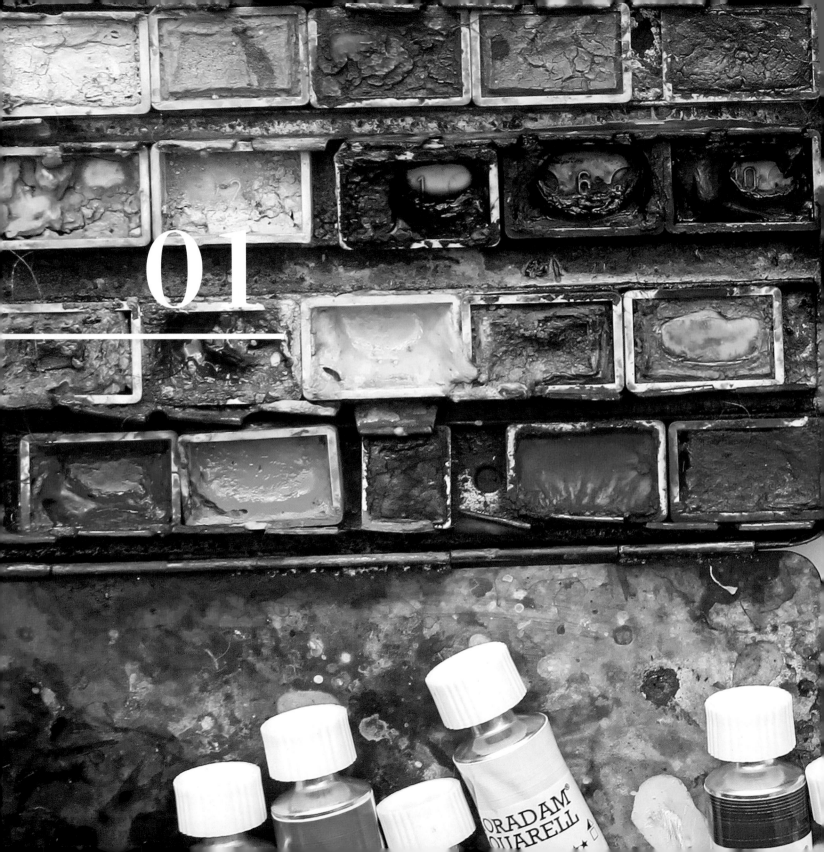

01

Materials +Equipment

In this chapter, I show you all of the materials and equipment that I use for my painting.

HORADAM
AQUARELL

PAINTING SURFACES

I use:

- ↘ **Watercolour paper by Fabriano, satin or fine grain finish; 300gsm (140lb) or 600gsm (300lb)**

This paper is suitable for all watercolour techniques and it also keeps its shape after it has been dampened. You can obtain even colour gradations using the wet-in-wet technique and the colours also stand out brilliantly if you use the dry brush technique.

BRUSHES

My collection of brushes consists of:

- ↘ **One large round brush, no. 20**
- ↘ **One angled brush**
- ↘ **One liner brush**
- ↘ **One coarse bristle brush**

I use the angled brush for shaping all of the flowers and leaves.

I use the round brush for larger spaces, e.g., the sky and landscapes. It is also ideal for splattering — e.g., for the backgrounds of flower pictures — as it can hold lots of water and paint.

The liner brush is suitable for fine lines, such as grass, stems and branches.

I use the coarse bristle brush for splattering the leaves of trees. The paint droplets created by this brush are very fine. If you carefully spray water over a painted space, little droplets will remain here and there, which will make the canopy appear transparent in places.

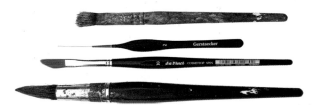

ACCESSORIES

⌐ **Masking fluid**

⌐ **Masking tape**

I use masking fluid to cover areas which should remain white, or other areas of the picture which are not to be worked. The fluid is waterproof. Coloured masking media are available, which are easily visible on watercolour paper, and you can also dye white masking fluid yourself with a drop of watercolour paint. The medium should always be completely dry before it is rubbed off, but it should not be left on the paper for too long.

I like to use the masking tape to help me when painting birch trees (see pages 30–33). It lets me work faster and with a clearer overview when I am splattering paint near the trees.

PAINTS

I use:

⌐ **Watercolour paints (by Schmincke, but any quality brand will do), in large pans or, alternatively, large tubes**

The advantage of large pans is that you can get the paint out of them easily with larger brushes. If they are almost empty, I like to refill them from large paint tubes until the last bits are used up before I swap them for new large pans.

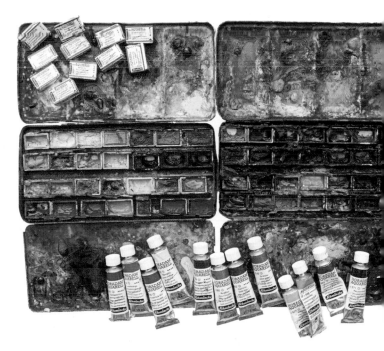

02

Technique Focus

Step-by-step

Here I explain my working methods using a few simple designs. For example, composing a flower meadow, how a birch tree is created, or how I paint diverse flowers with leaves and a background. I use a lot of water in my painting, which now and again leads to paint puddles. As I don't sketch out my designs first, I can work these water edges into the picture. For example, additional flowers can emerge that I had not planned beforehand.

Composition

FLOWER MEADOW

MATERIALS

- **Watercolour paper**
 Satin finish, 300gsm (140lb)

- **Watercolour paints**
 Lemon yellow, Transparent orange, Permanent red, French ultramarine, Indigo, Rose madder, Magenta, May green, Olive green, Black

- **Brush**
 Round brush, no. 20
 Angled brush
 Liner brush

- **Spray bottle**
 with water

Place the red flowers carefully, because this colour is difficult to paint over. Arrange these flowers loosely over the complete sheet of paper, but leave the rest of the flowers to chance. The overall result will surprise you every time.

This technique is used in the following projects:

1 Spring Message (page 40)

2 Shaded Woods (page 58)

3 Early Summer Meadow on the Forest Edge (page 60)

4 Down by the River (page 64)

5 White Flowers in Winter (page 102)

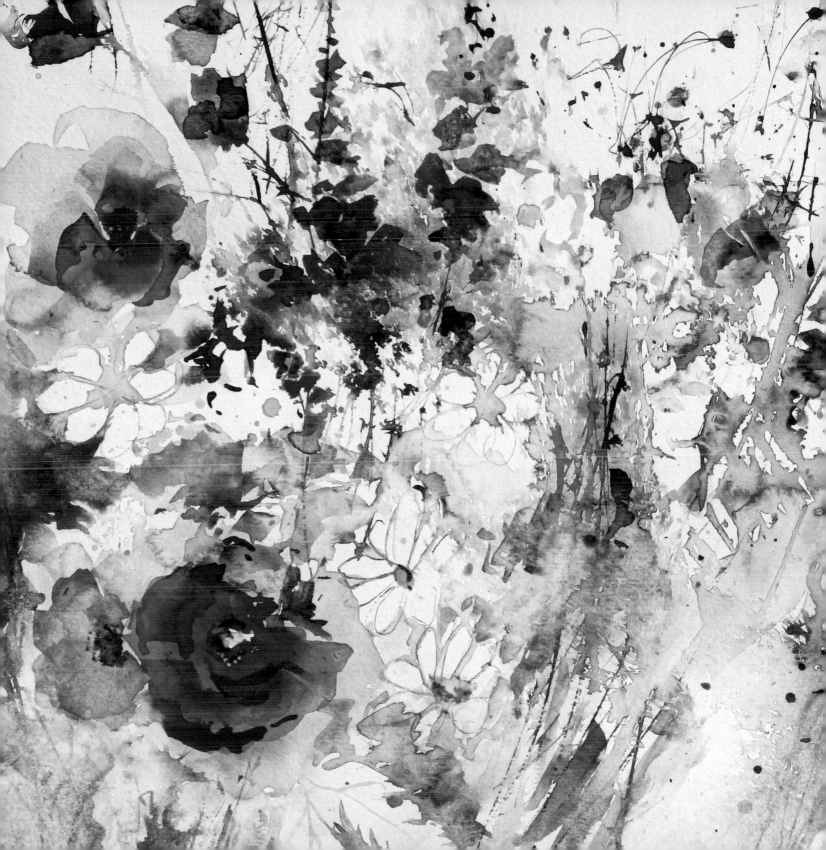

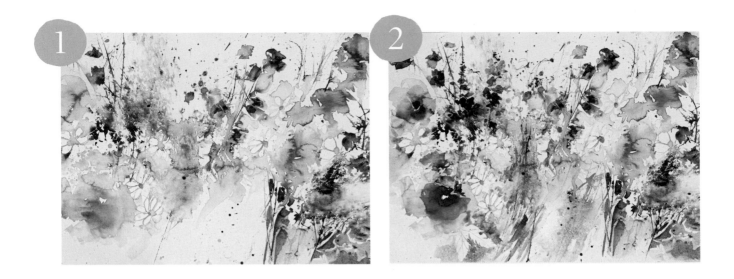

1 With the angled brush, position the poppy flowers using Transparent orange. Splatter the flower panicles using French ultramarine and paint the bell-shaped flowers in Rose madder. Immediately splatter the background of each bell-shaped flower with Lemon yellow using the round brush. Use the liner brush to paint in matching stems along with a leaf here and there. Carefully spray water over the painted area. The paint should also flow a little into the flowers, which will also soften the stems and the leaves slightly. Use the angled brush and the liquid paint on the paper to form small daisies in a few places. Place a Lemon yellow dot in the middle of each daisy.

2 Allow to dry well. Now make the flowers more intense using the appropriate darker shades: Transparent orange with Permanent red, French ultramarine, with a mixture of French ultramarine and some Indigo, Rose madder with Magenta. Mix Olive green with some May green and paint in the missing stems with the liner brush. Paint in some more leaves with the angled brush. Spray a little water over them.

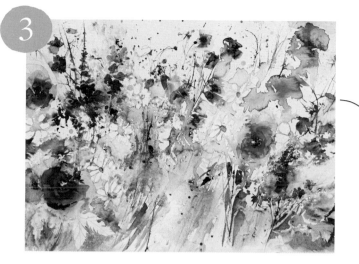

3

DETAIL

3 After everything has dried again, mix Olive green with some French ultramarine. You will get a warm, dark shade of green, which you can use to shade the light green leaves, grass and stems. Paint here and there in the background with this darker colour. Paint a Lemon yellow dot into the poppy flowers, then shade the dot in the middle of the daisies with Transparent orange. Paint some stamens in Transparent orange here and there in the blue flowers. Then paint a few small, black dots in the middle of the poppy flowers.

Details

POPPY FLOWERS

MATERIALS

- ⚑ **Watercolour paper**
 Satin finish, 300gsm (140lb)

- ⚑ **Watercolour paints**
 Lemon yellow, Pure yellow,
 Transparent orange,
 Permanent red, May green,
 Olive green, Indigo, French
 ultramarine, Black

- ⚑ **Brushes**
 Round brush, no. 20
 Angled brush
 Liner brush

- ⚑ **Leaves**

- ⚑ **Spray bottle**
 with water

I decided to paint the leaves and a few stems first. This way, the orange and red shades mix together easily without too much green flowing into the poppy petals, which would make them look dirty. Use the full spectrum of warm colours for the flowers, and also paint some darker flowers onto the paper.

This technique is used in the following projects:

1 Summer is near — Poppies & Dandelions (page 44)

2 Cow Parsley with Poppies (page 70)

3 Colourful Autumn Bouquet (page 80)

4 Fiery Canopy (page 82)

5 Tree in a Snowstorm (page 100)

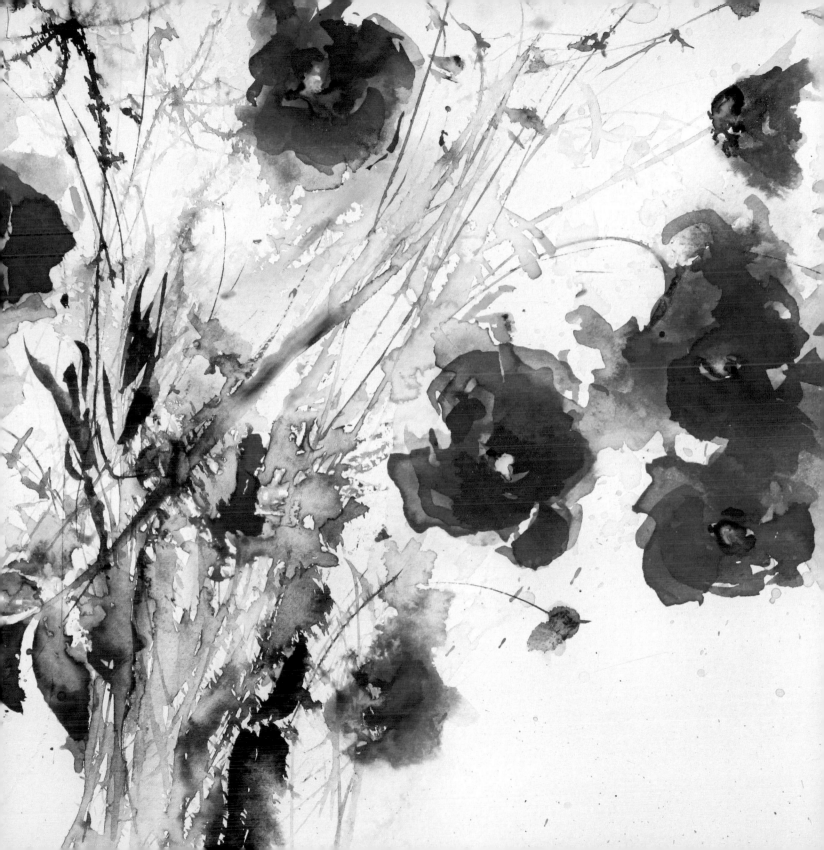

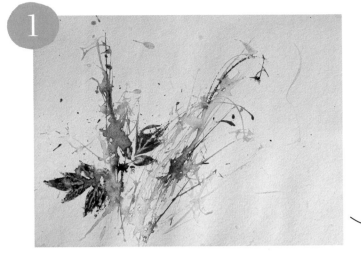

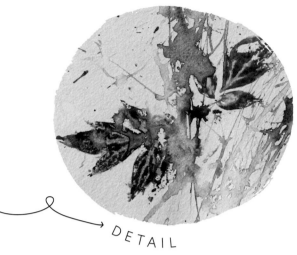

DETAIL

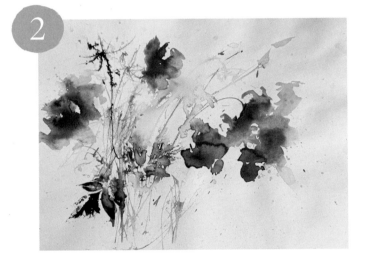

1 Paint a leaf with May green and some Olive green, and press it onto the paper in an appropriate place. Take the leaf away, then paint in some grasses with the liner brush. Splatter some Lemon yellow on and spray the painted area all over, carefully, with water.

2 Let everything dry. Using the angled brush and Transparent orange, paint some poppy flowers. Splatter more Lemon yellow in the background using the round brush, and use Pure yellow in a few places. Spray some water on again, so that the colours can flow into each other in places.

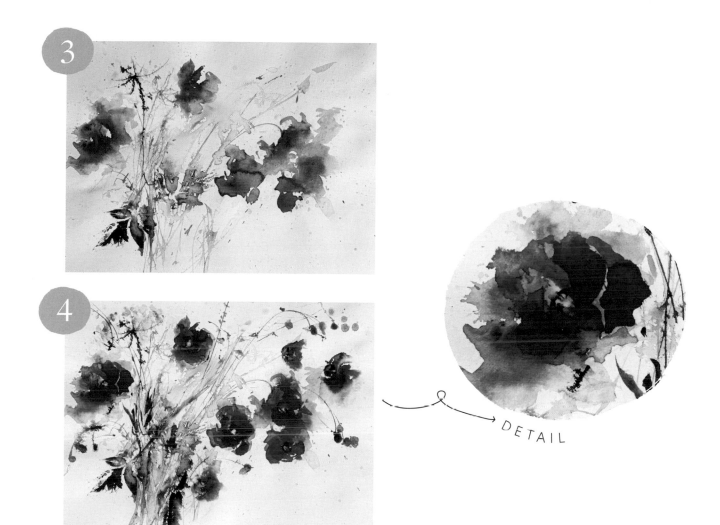

DETAIL

3 Leave to dry. Mix some Olive green with Indigo and shape some small poppy seed pods and buds with your index finger. Using the liner brush, draw some appropriate stems and grasses and spray over lightly with water. Intensify the poppy flowers with Permanent red. Put in a dot of Lemon yellow for the stamens. Let everything dry.

4 Mix French ultramarine with some Olive green and, using the angled brush, paint in the darkest shadows in the picture. After this has dried, use some black paint on the angled brush to paint in the stamens of the poppy flowers. Finally paint in some red petals on some of the buds.

Chance

BLUE AND PURPLE FLOWERS

MATERIALS

⚹ **Watercolour paper**
Satin finish, 300gsm (140lb)

⚹ **Watercolour paints**
Lemon yellow, May green,
Olive green, Mountain blue,
Transparent orange, French
ultramarine, Ultramarine violet,
Brilliant blue violet,
Rose madder

⚹ **Brushes**
Round brush, no. 20
Angled brush
Liner brush

⚹ **Spray bottle**
with water

Flowing colours, lots of water — this creates the element of chance in watercolour painting. Identify the flowers in random colour gradations and use the brush and paint to give them the desired shape. Arrange the flowers loosely, leaving some free space and enough room for stems and leaves.

This technique is used in the following projects:

1 Lime (Linden) Tree in the Spring Light (page 46)

2 Apple Tree in Blossom (page 48)

3 November Mood (page 76)

4 The Forest is Colourful (page 88)

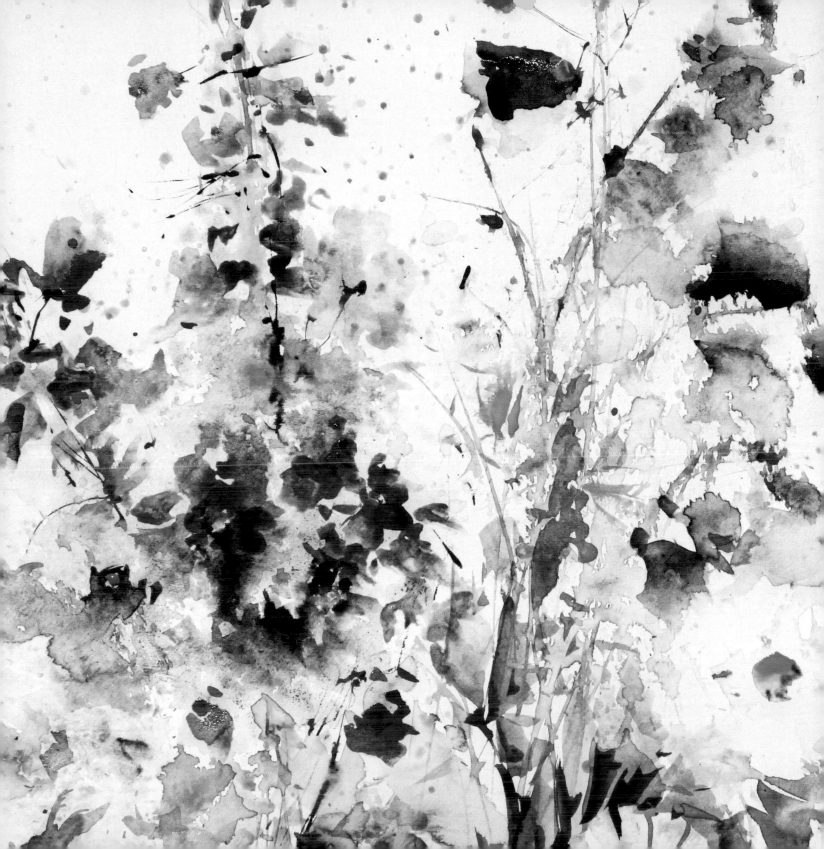

DETAIL

1 Create the shape of a delphinium by splattering, using the round brush and Mountain blue.

2 Mix May green with some Olive green, and, using the liner brush, paint in some appropriate stems. Paint in a few stems for the bell-shaped purple flowers. Splatter Lemon yellow in the background using the round brush, and then spray everything carefully with water.

3 Once dry, using the angled brush, shape and intensify the light blue flower panicles with French ultramarine. Paint in the campanulas with Ultramarine violet. Splatter some Ultramarine violet to the far right of the picture, along with some Lemon yellow.

DETAIL

4 Quickly spray on some water and use the angled brush to shape a few daisies. Place a dot in the middle of the flowers using Lemon yellow. Leave to dry. Mix Olive green with some French ultramarine and use it to paint in some shadows on the leaves and stems. Using the liner brush, draw some dark green grasses throughout the picture. Splatter some more Lemon yellow in the green spaces. Use the angled brush to

shape some small pink flowers in Rose madder, and intensify the campanulas by adding some Brilliant blue violet. Also highlight the daisies using this shade of dark green. In the middle of some of the flowers, paint a Transparent orange dot, and shade some of the daisy stamens with Transparent orange.

WHITE DAISY

MATERIALS

↘ **Watercolour paper**
Satin finish, 300gsm (140lb)

↘ **Watercolour paints**
Lemon yellow, Pure yellow,
Transparent orange,
Transparent brown, French
ultramarine, May green,
Olive green

↘ **Brushes**
Round brush, no. 20
Angled brush
Liner brush

↘ **Spray bottle**
with water

Gleaming white, accentuated by dark shadows. The flower can also be covered over with masking fluid, but it looks fresher and more spontaneous without any masking. Do not be afraid to sketch the daisy freehand, as nature is the most creative artist.

This technique is used in the following projects:

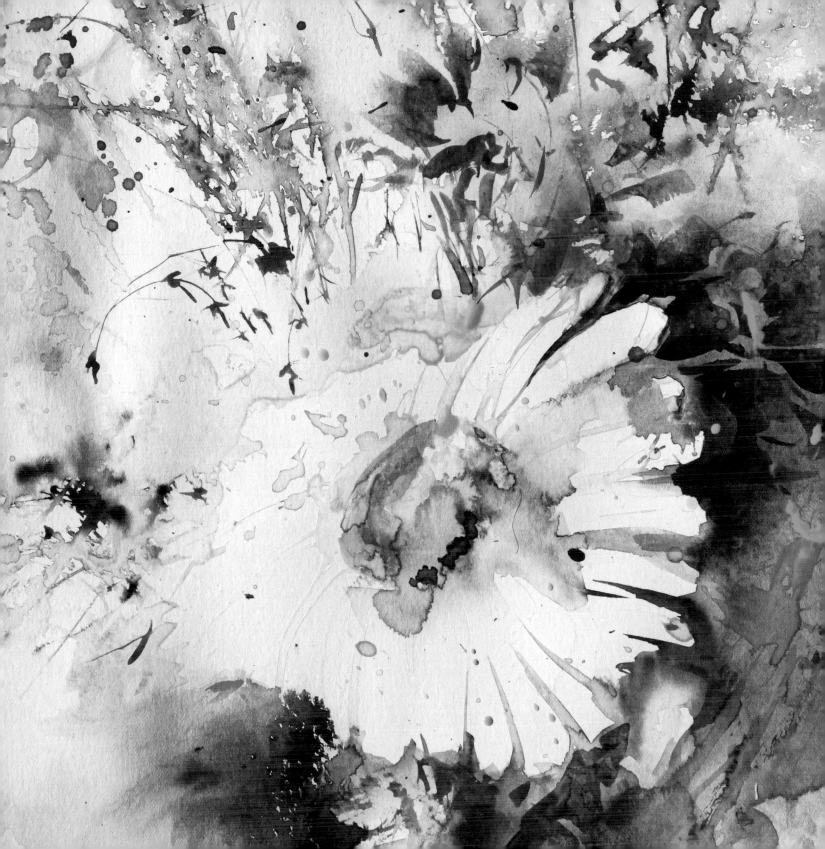

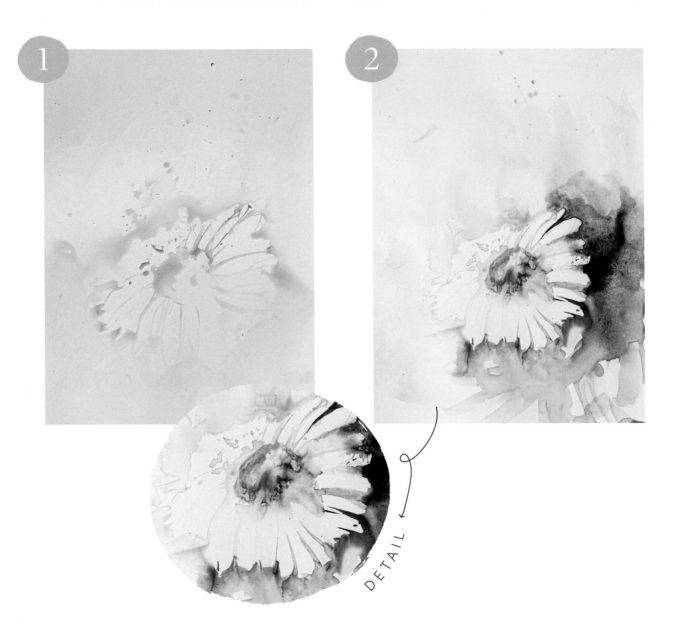

DETAIL

1 Paint the outlines of the daisy using the liner brush and the Lemon yellow, placing a Lemon yellow dot in the middle. Lightly spray water over it so that the yellow paint runs straight into the background and there are no hard outlines.

2 After drying, intensify the background using Pure yellow for the sunny side and French ultramarine and Olive green for the shaded side. Shade the centre of the daisy with Transparent orange and add a few drops of French ultramarine. Paint in a few tiny dots with Transparent brown.

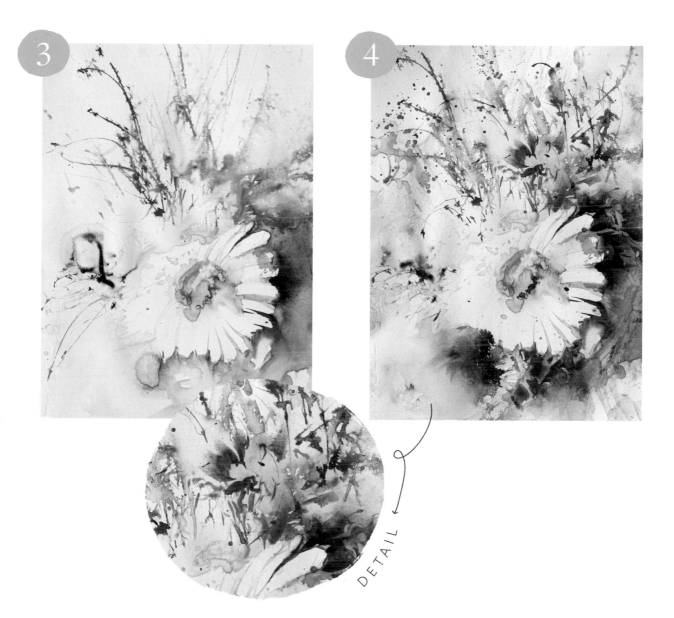

DETAIL

3 Mix May green with some Olive green and, using the angled brush, shape some appropriate leaves. Use this colour with the liner brush to paint in grasses and stems. Splatter on some Lemon yellow and carefully spray everything with water, including over the daisy.

4 After everything has dried, mix Olive green and French ultramarine. Shape some leaves and darker grasses with the angled brush. Accentuate the white of the daisy with a few dark shadows. With the liner brush and May green, paint in some lighter coloured grasses in places where it is now too dark.

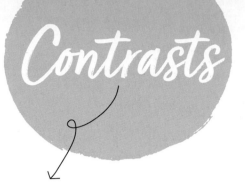

BIRCH TREES

MATERIALS

- ↘ **Watercolour paper**
 Satin finish, 300gsm (140lb)

- ↘ **Watercolour paints**
 Lemon yellow, Pure yellow, Transparent orange, May green, Olive green, Mountain blue, French ultramarine, Sepia

- ↘ **Brushes**
 Round brush, no. 20
 Angled brush
 Coarse bristle brush
 Liner brush

- ↘ **Masking tape**

- ↘ **Spray bottle**
 with water

Work the prominent bark of the birch trees using dry paint, but the leaves with plenty of water and just as much paint. The leaf canopy should remain as light as possible, with the dark colours only flowing into it in places. This is how you capture the sunshine of the summer forest.

This technique is used in the following projects:

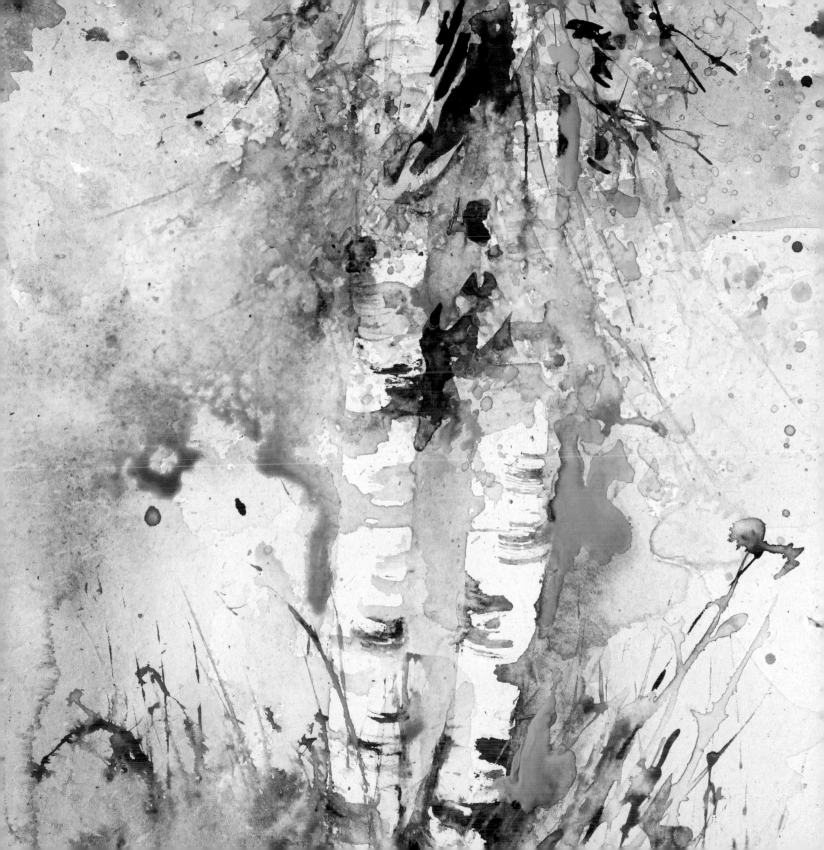

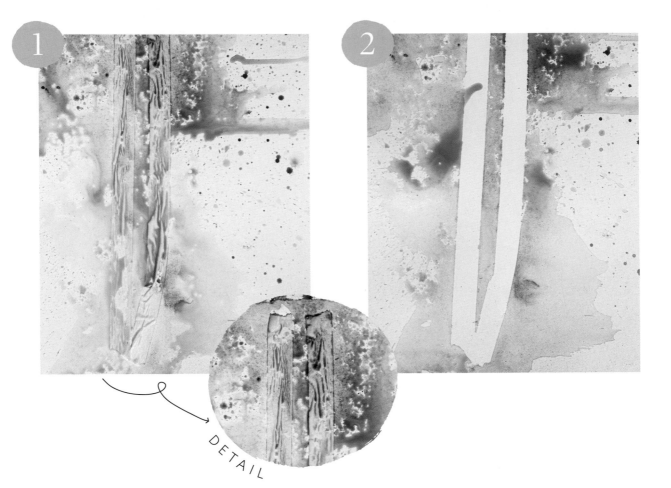

DETAIL

1 Take two strips of masking tape of appropriate lengths and stick them lightly — do not press down firmly — next to each other on the paper. Splatter the upper third using the round brush and Mountain blue for the sky, and also one area at the bottom right, next to the birch tree. Splatter the rest of the space in Lemon yellow. Spray on some water on and rotate the picture so that the paints can mix here and there. Allow to dry briefly then splatter Mountain blue and Lemon yellow over the picture again. The paints should not be too watery.

2 Now, carefully lift off the masking tape. Shape the dark bark of the first birch tree using a dry angled brush and dry Sepia paint. The blue and yellow backgrounds should also flow into the tree trunks. For the leaves, splatter on Lemon yellow using the bristle brush, let it dry briefly, then splatter a few areas with Pure yellow, and, here and there, some Transparent orange. Spray everything with water.

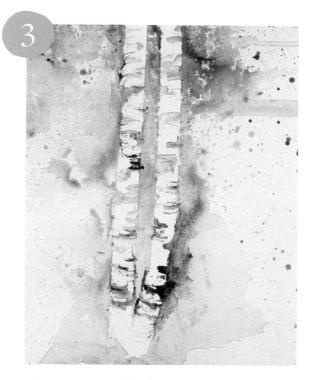

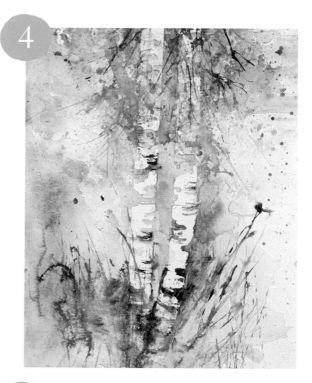

3 After it has dried, splatter some leaves on in May green — again, allow to dry briefly — then shade the leaf canopy with a mixture of Olive green and some French ultramarine.

4 Paint in a few birch branches using the liner brush and Sepia. With this green mixture and the liner brush, paint in a little of meadow at the bottom of the trees. Drop in some Transparent orange, and spray everything carefully with water.

5 To finish, intensify the sky at the top with French ultramarine.

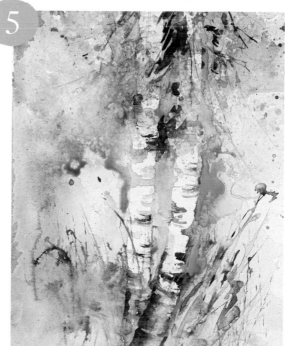

Focus

SUNFLOWER

MATERIALS

- ↘ **Watercolour paper**
 Satin finish, 300gsm (140lb)

- ↘ **Watercolour paints**
 Lemon yellow, Indian yellow,
 Pure yellow, Transparent
 orange, May green, Olive
 green, French ultramarine,
 Transparent brown,
 Vandyke brown

- ↘ **Brushes**
 Round brush, no. 20
 Angled brush
 Liner brush

- ↘ **Spray bottle**
 with water

No other flower is so reminiscent of summer. This is why I like to paint the corolla of the sunflower somewhat larger than life, to capture this radiance. Make sure that the light colours have dried completely before adding in the dark ones.

This technique is used in the following projects:

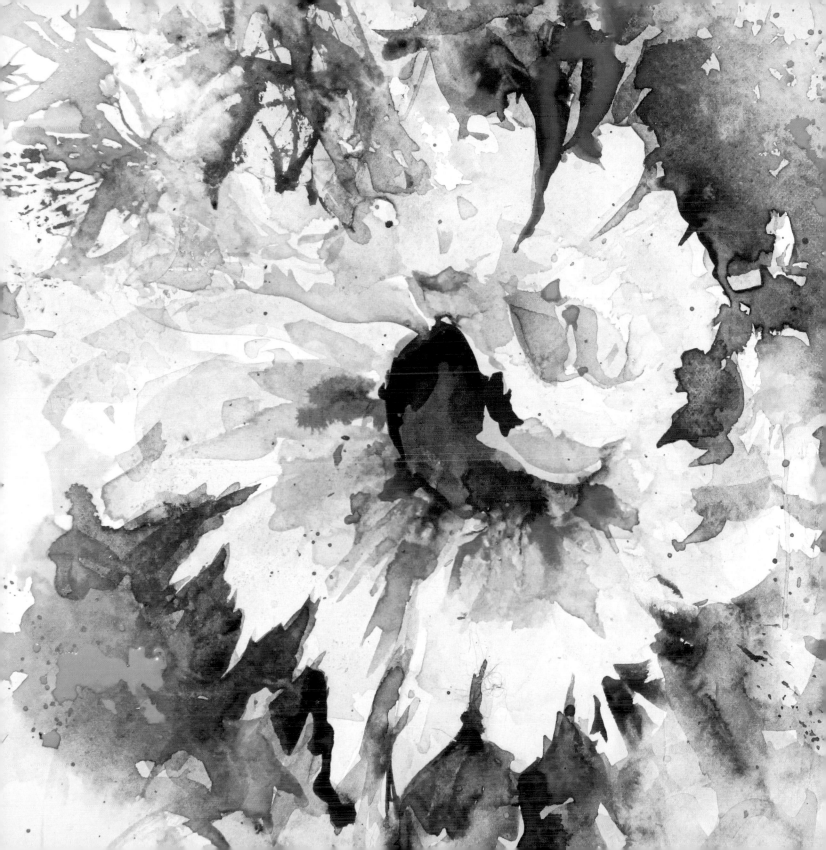

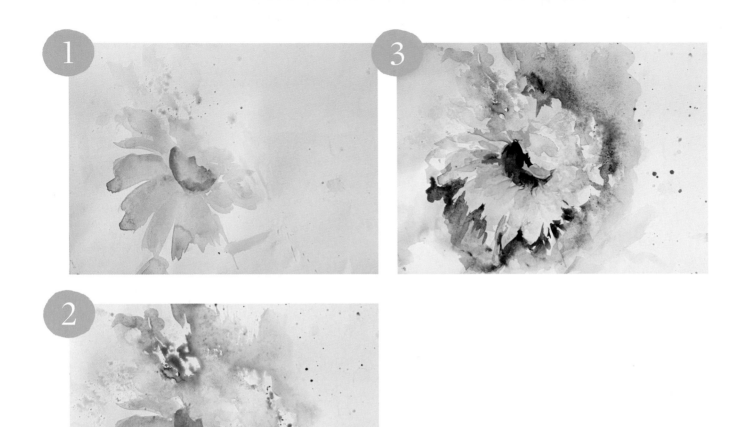

1 Paint in the shape of a sunflower using the
 round brush and Lemon yellow. Also paint in
 the flower centre in Lemon yellow.
 Generously splatter Lemon yellow in the
 background, then spray everything
 with water.

2 After everything has dried, paint the centre
 of the flower with Indian yellow, and, using
 the angled brush, shape the petals using

Pure yellow — but still leave some tips of
Lemon yellow. Splatter French ultramarine
in the background and spray water on it.

3 After it has dried, paint in part of the outline
 of the sunflower in French ultramarine, and
 intensify part of it with Pure yellow. The
 dark blue background highlights the petals
 strikingly. Leave to dry.

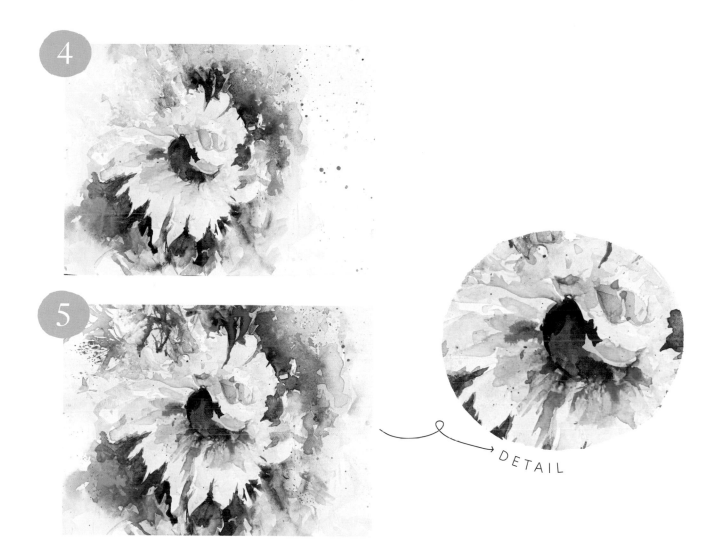

DETAIL

4 Paint in the stems and the leaves using May green. Shape the centre of the flower with Transparent brown and, using the angled brush, paint in a few Transparent orange petals. Spray a little water on and leave to dry again.

5 Mix Olive green with some French ultramarine and paint in the shadows of the stems and leaves with it. Use this green with the liner brush to paint some loose grasses into the picture. Intensify the middle of the sunflower with Vandyke brown, and a few petals with Transparent orange.

03

Spring

In spring, with the first rays of sunshine after the long winter months, the natural world awakens. You have to look closely, search and peek to discover flower buds. A few days later the buds will be open and it will be time to observe and capture their transformation into flowers. Painting allows us to capture a process of development that takes place only in spring, in a picture that will last forever.

Spring
MESSAGE

MATERIALS

- ⚡ **Watercolour paper**
 Satin finish, 300gsm (140lb)

- ⚡ **Watercolour paints**
 Lemon yellow, Rose madder, Madder lake deep, Permanent red orange, Permanent red, May green, Olive green, French ultramarine, Vandyke brown, Indigo

- ⚡ **Brushes**
 Round brush, no. 20
 Angled brush
 Liner brush

- ⚡ **Spray bottle**
 with water

Make the most of spring's bountiful offering by turning it into a table decoration.

1 Shape the vase using French ultramarine and the angled brush. Then paint in the magnolia flowers using Rose madder and the poppy flowers with the Permanent red orange. Splatter the background using the round brush with Lemon yellow. Lightly spray water over it.

2 Leave to dry. Intensify the poppies with Permanent red and dab some Lemon yellow in the middle. The open magnolias should also get a yellow middle.

3 Intensify the magnolia petals again with Rose madder. For the dark centre, use Madder lake deep. Use this also for the poppies.

4 Splatter the implied leaves in the background using the round brush and May green, and then intensify these using the angled brush and Olive green. Mix May green with some Olive green and, using the liner brush, draw stems and grasses through the picture. Paint in delicate branches corresponding to the magnolia flowers using Vandyke brown.

5 Intensify the vase with French ultramarine and spray some water over it. Then mix some Indigo into the French ultramarine and paint the shadow under the vase with it.

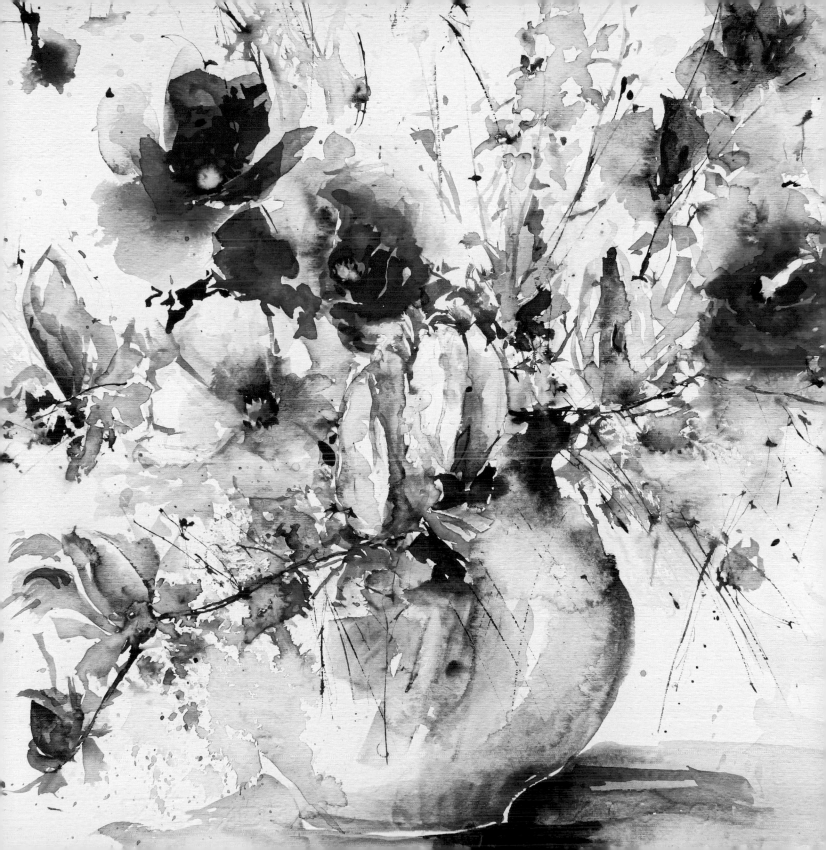

FLOWERS
from the Wayside

MATERIALS

- **Watercolour paper**
 Satin finish, 300gsm (140lb)

- **Watercolour paints**
 Lemon yellow, Pure yellow, Indian yellow, May green, Olive green, Mountain blue, French ultramarine, Magenta, Madder lake deep

- **Brushes**
 Round brush, no. 20
 Angled brush
 Liner brush

- **Pencil**

- **Spray bottle**
 with water

Combine flowers and blooms to create a fragrant spring bouquet in a special vase.

1 Dip the pencil into some watery Mountain blue and draw the angular vase. Shade it with the angled brush and Mountain blue.

2 Outline the shape of the small daisies, partly with Mountain blue, partly with Lemon yellow. With the round brush splatter Lemon yellow in the background and carefully spray everything with water. Leave the white of the daisies clear.

3 Using the round brush, paint some loose flower shapes in Mountain blue or Magenta to complement the daisies. Spray over lightly with water. Once it has dried, paint dots in the centre of the daisies in Lemon yellow, Pure yellow, Indian yellow or May green. Intensify the magenta flower panicles with Madder lake deep. Draw matching stems to all the flowers using the liner brush and May green. Mix May green with some Olive green and paint in small leaves and darker stems.

4 Mix Olive green with French ultramarine and use this very dark shade of green to define some of the flowers. Paint the shaded side on the right of the picture with the round brush and French ultramarine and spray some water on it. Intensify the left side of the picture with Lemon yellow.

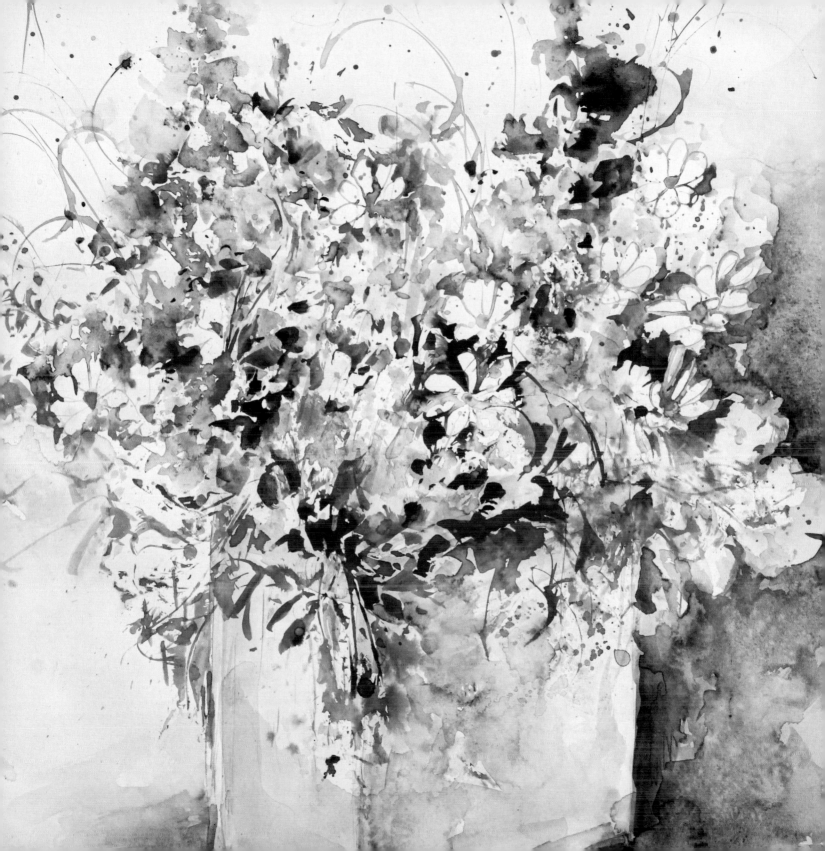

Summer is near –
POPPIES & DANDELIONS

- ⚵ **Watercolour paper**
 Satin finish, 300gsm (140lb)

- ⚵ **Watercolour paints**
 Lemon yellow, Pure yellow, Indian yellow, Transparent orange, Permanent red orange, Permanent red, May green, Olive green, Black

- ⚵ **Brushes**
 Round brush, no. 20
 Angled brush
 Liner brush
 Coarse bristle brush

- ⚵ **Leaves**
 from a dandelion

- ⚵ **Spray bottle**
 with water

A harmonious duet with paint pressed onto the paper using dandelion leaves.

1 Paint in the poppy flowers with the angled brush and Transparent orange. Splatter the background using the round brush and Lemon yellow. To make the area intended for the dandelions stand out more against the poppies, lightly spray over it with water.

2 Leave to dry. Now intensify the poppy flowers with Permanent red orange and leave again briefly to dry. Use the angled brush and Permanent red to create the final shape of the poppies. Mix May green with a little Olive green and shape the underside of each dandelion flower. Also paint a dandelion leaf with this paint

mixture and press it here and there on the picture. Intensify the petals of the dandelion flowers using Pure yellow and Indian yellow.

3 Paint in the stems of the poppies with the liner brush and May green. Also draw some grasses through the picture. Shade the light green leaves and stems with the darker Olive green.

4 Dab some black into the centre of the poppies with your index finger and highlight the poppy centres using the angled brush and May green. Carefully splatter the fine stamens using the bristle brush and Black.

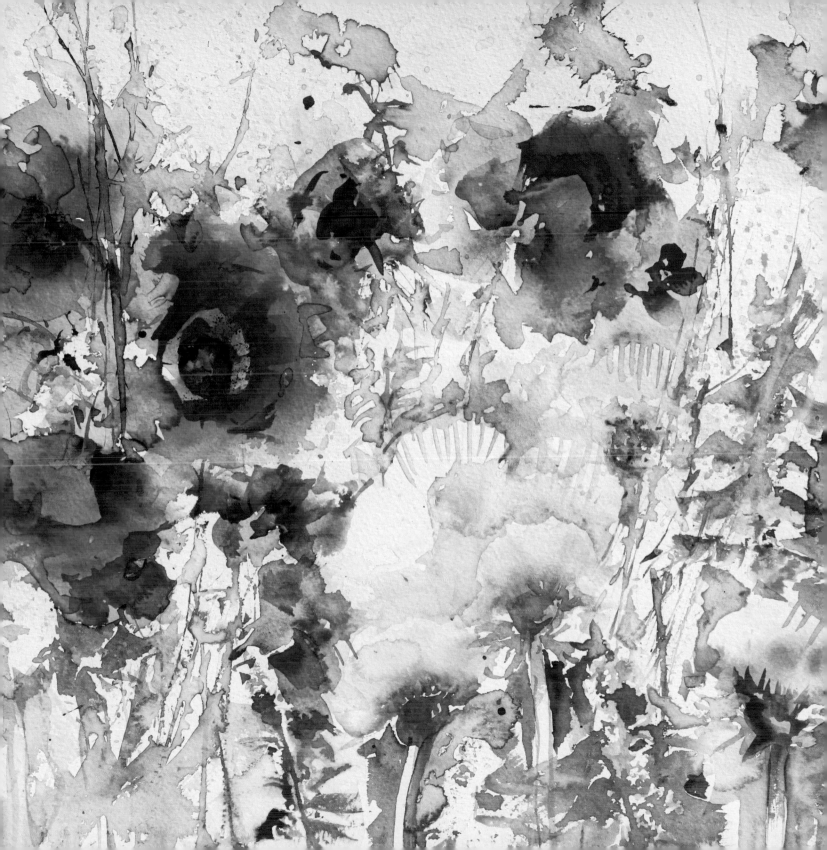

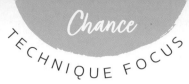
LIME (LINDEN) TREE
in the Spring Light

MATERIALS

- ↗ **Watercolour paper**
 Fine grain finish,
 300gsm (140lb)

- ↗ **Watercolour paints**
 Lemon yellow, Pure yellow,
 Transparent orange, May
 green, Olive green, Vandyke
 brown, Mountain blue

- ↗ **Brushes**
 Round brush, no. 20
 Angled brush
 Coarse bristle brush

- ↗ **Spray bottle**
 with water

*The powerful rays of the
spring sun reawaken the sturdy
lime (linden) tree.*

1 Shape the tree trunk using the angled brush and diluted Vandyke brown. Splatter Lemon yellow with the bristle brush for the leaves, leaving small white patches here and there. Lightly spray everything with water.

2 Using the angled brush and Lemon yellow, paint the meadow under the tree.

3 When the Lemon yellow areas for the leaves have dried a little, splatter some Pure yellow on them in places, and spray a little water over them. Allow to dry again briefly, then highlight some areas with diluted Transparent orange.

4 After everything has dried, splatter May green — and, here and there, Olive green — into the foliage, then spray a little water over it.

5 The meadow can also be intensified with shades of green. Splatter a few drops of Transparent orange onto it using the round brush.

6 Using the round brush and Mountain blue, paint in the shadow under the tree. Dampen the sky with water and let the diluted Mountain blue flow into it. Finally intensify the tree trunk and add some branches, using the angled brush and Vandyke brown.

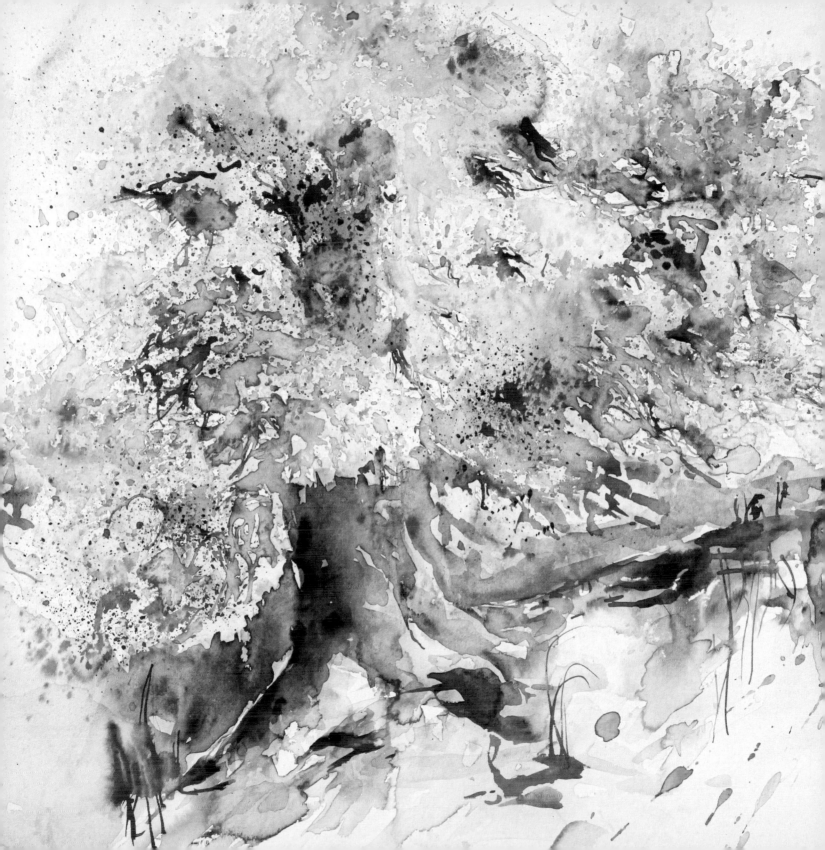

APPLE TREE
in Blossom

MATERIALS

- **Watercolour paper**
 Fine grain finish,
 300gsm (140lb)

- **Watercolour paints**
 Lemon yellow, Pure yellow,
 Rose madder, May green, Olive
 green, French ultramarine,
 Mountain blue, Vandyke brown

- **Brushes**
 Round brush, no. 20
 Angled brush
 Coarse bristle brush
 Liner brush

- **Spray bottle**
 with water

A profusion of delicate blossoms in the spring brightens up the old apple tree.

1 Shape the tree trunk using the angled brush and a watery Mountain blue. Allow it to dry briefly.

2 For the first application, splatter Rose madder using the bristle brush for the implied flowers, and Lemon yellow for the leaf canopy. Let it dry briefly. Then splatter May green and Olive green in places, and again spray with a little water. Mix Vandyke brown with some French ultramarine and use this to intensify the bark of the tree.

3 With the liner brush, draw some branches through the crown of the tree in Olive green. Paint in the sky using the round brush and some French ultramarine, then spray some water over it.

4 Paint in the meadow with Lemon yellow and some Pure yellow, and intensify the shadows under the tree with French ultramarine. Paint in a few dark green patches in the meadow, and then lightly spray over it with water.

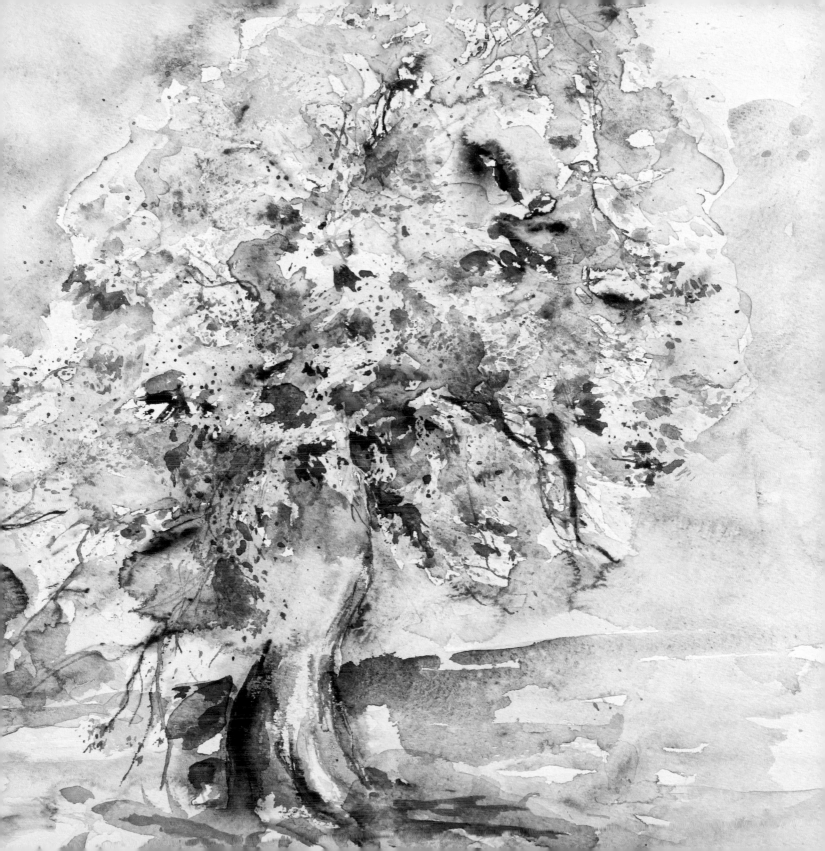

Sun-dappled
SPRING FOREST

MATERIALS

- ↘ **Watercolour paper**
 Satin finish, 300gsm (140lb)

- ↘ **Watercolour paints**
 Lemon yellow, Pure yellow,
 Indian yellow, Mountain blue,
 French ultramarine, Helio
 turquoise, May green, Olive
 green, Vandyke brown

- ↘ **Brushes**
 Round brush, no. 20
 Angled brush
 Liner brush
 Coarse bristle brush

- ↘ **Spray bottle**
 with water

*While the sun is not yet so
strong, the colours of the forest
are bright and delicate.*

1 Shape the trunk of the large birch tree with the angled brush and Mountain blue. Use the bristle brush to splatter Mountain blue into the upper area, and Lemon yellow into the lower area. Spray water over it. Intensify the large tree trunk with Vandyke brown. Let it dry briefly, then again splatter Mountain blue and a little May green into the upper canopy. Spray these areas lightly with water and rotate the paper so the colours mix.

2 Splatter Pure yellow, and Indian yellow in places, to produce the sunny effect in the bright yellow area, and spray lightly with water. Allow to dry briefly, then splatter May green over the top. Let it dry again. Mix Olive green with French ultramarine to splatter the dark shaded areas, then lightly spray with water. Rotate the paper so the dark colour spreads well.

3 Using the angled brush and a watery Vandyke brown, paint the tree trunks on the right of the picture.

4 Draw some more green branches through the foliage with the liner brush. Use the round brush to splatter a few rough splashes of Helio turquoise and Indian yellow here and there in the picture.

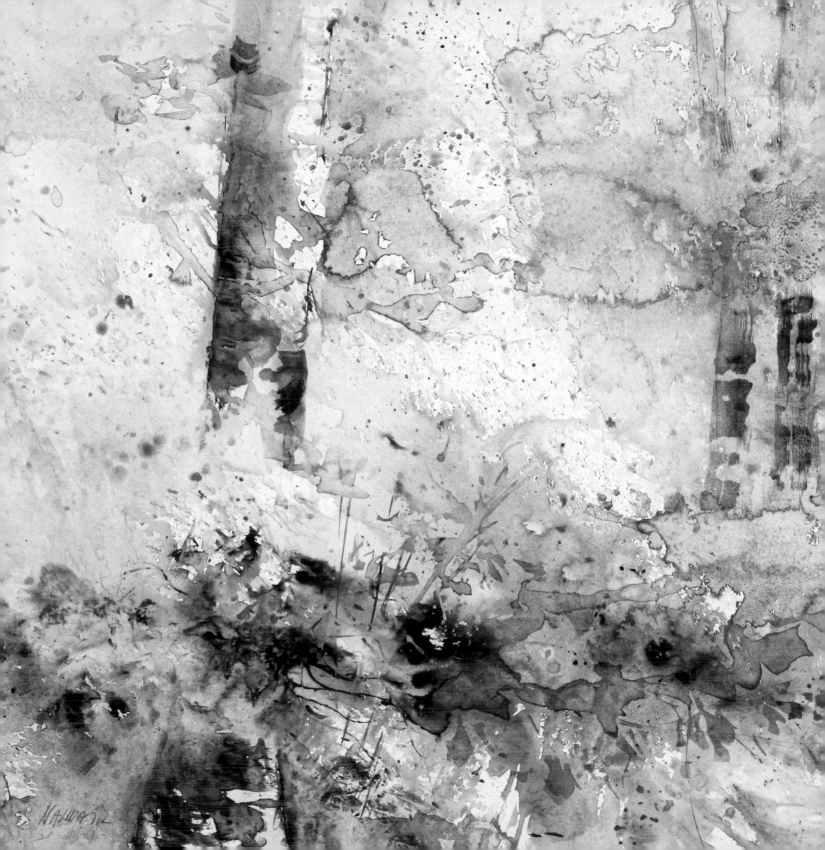

A PROFUSION
of Spring Flowers

MATERIALS

- **Watercolour paper**
 Satin finish, 600gsm (300lb)

- **Watercolour paints**
 Lemon yellow, Pure yellow, Magenta, Rose madder, French ultramarine, Cobalt turquoise, May green, Olive green, Vandyke brown

- **Brushes**
 Round brush, no. 20
 Angled brush
 Liner brush

- **Spray bottle**
 with water

Full of buds and huge blossoms, the magnolia grows up into the sky.

1. Shape the blossoms of the magnolia with the angled brush and Rose madder. Leave a lot of the petals white. Define these white areas with Lemon yellow or May green.

2. Shape the foliage around the flowers with the angled brush and May green.

3. Paint some shadows into the leaves with Olive green. Draw some rough branches through the picture with the liner brush and Vandyke brown.

4. Define the light-coloured leaves with Olive green and French ultramarine. Also paint in some contrasts with Cobalt turquoise. Lightly spray water over them.

5. Highlight the inside of the magnolia flowers with a mixture of Rose madder and Magenta. Paint in the stamens with Lemon yellow and Pure yellow.

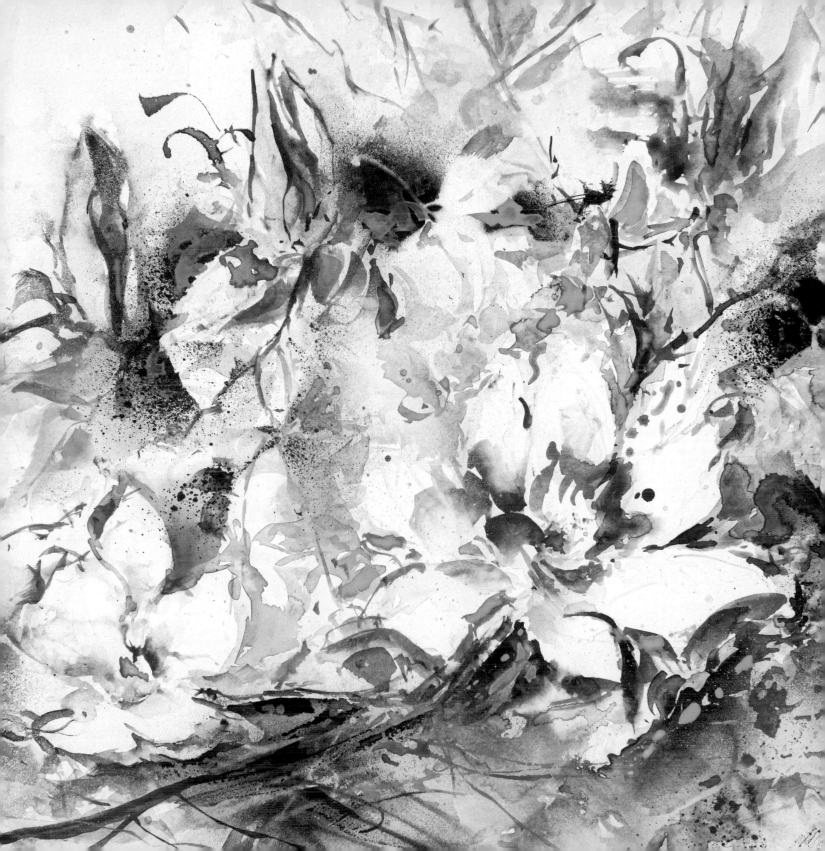

SPRING
in the Mountains

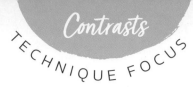

MATERIALS

- **Watercolour paper**
 Satin finish, 600gsm (300lb)

- **Watercolour paints**
 Pure yellow, Mountain blue,
 French ultramarine, Sepia, May
 green, Olive green

- **Brushes**
 Round brush, no. 20
 Angled brush
 Liner brush

- **Masking fluid**

- **Old brush**
 for masking fluid

- **Spray bottle**
 with water

The mountain peaks are still white, but the warm spring sun encourages the first tender green.

1 Mix the masking fluid with a little water, and, with an old brush, cover a large part of the mountain. Leave to dry.

2 Draw the outlines of the tree trunk with watery Mountain blue and immediately paint the background with French ultramarine or Olive green. The tree trunk remains white.

3 Let the painting dry. With the round brush, splatter Mountain blue over the area intended for the mountain and spray water on top. Paint dark patches in some areas using Sepia and French ultramarine.

4 Let it all dry well. Rub off the masking fluid. Paint a glaze over the white areas using the round brush and some diluted Mountain blue. Allow to dry.

5 Intensify the shadows in the rocks using French ultramarine, Olive green or Sepia. Shade some areas in with May green. With the angled brush, paint the leaves of the tree with undiluted May green. Create hints of branches using the liner brush and Sepia.

6 Using the round brush and Pure yellow, paint the sky yellow to the upper right and then paint a darker sky to the left with French ultramarine. After it has dried, paint some wispy clouds into the yellow area with watery French ultramarine.

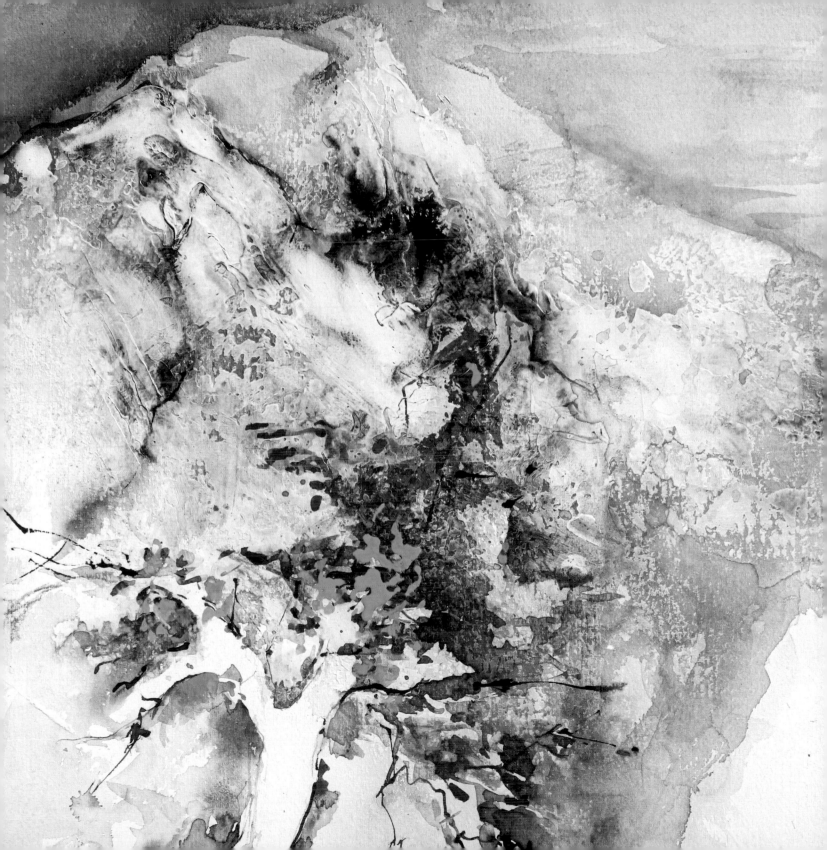

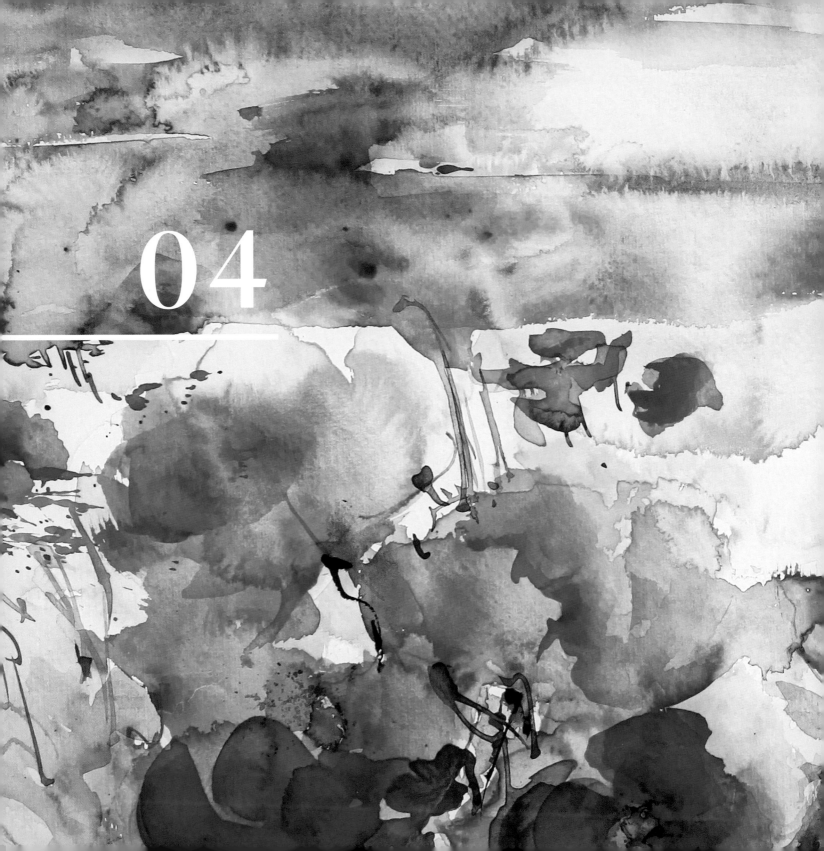

04

Summer

When the sun is at the peak of its power, you must choose from the variety of colours, forms and types that nature creates, recognizing changes and not overlooking the new. Expand your inspirations by including extremes of weather. Capturing heat, drought, torrential rainy days and dark skies that are briefly brightly illuminated (as if by lightning) in your paintings can expand the composition of your designs and make them individual.

Shaded
WOODS

MATERIALS

✂ **Watercolour paper**
Fine grain finish,
300gsm (140lb)

✂ **Watercolour paints**
Lemon yellow, Indian yellow,
May green, Olive green, French
ultramarine, Vandyke brown,
Transparent brown, Indigo

✂ **Brushes**
Round brush, no. 20
Angled brush
Liner brush
Coarse bristle brush

✂ **Spray bottle**
with water

*Shades of green define the
colour of the leaves as the sun
glistens through them.*

1 Shape the tree trunk with the
angled brush and Transparent
brown. Splatter on the foliage
of the tree using the bristle
brush and Lemon yellow and
spray it lightly with water. Let
it dry briefly.

2 Splatter May green onto the
yellow area and rotate the
paper so that the green paint
is better able to spread. Allow
to dry briefly.

3 Splatter Olive green onto the
leaves and lightly spray with
water again.

4 Paint the background with a
watery French ultramarine.
Coarsely splatter a few dashes
of Indian yellow paint on the
leaves with the round brush,
letting this colour drip into the
tree trunk as well.

5 Mix Vandyke brown with a
little Indigo and intensify the
tree trunk and branches with
the angled brush. Draw some
dried-out branches through
the leaves with this colour and
the liner brush.

6 Create the hint of a tree
stump on the left with the
round brush and Vandyke
brown. Mix French ultramarine
with some Indigo and use it to
paint in the deep shadows.

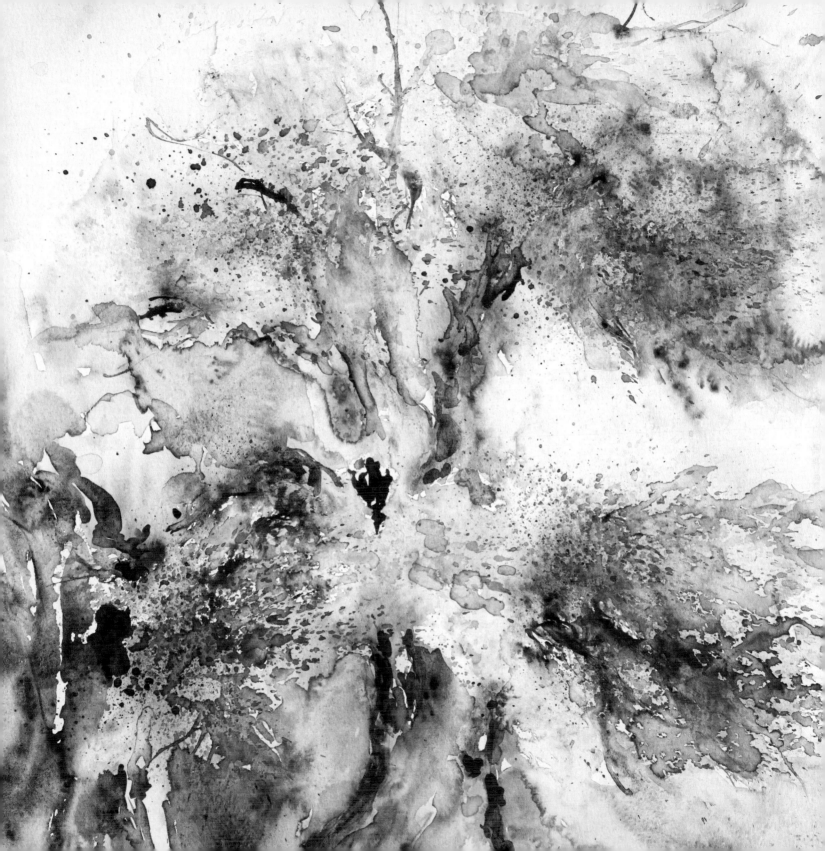

Early Summer Meadow

ON THE FOREST EDGE

MATERIALS

- **Watercolour paper**
 Satin finish, 300gsm (140lb)

- **Watercolour paints**
 Lemon yellow, Transparent orange, Permanent red orange, Permanent red, May green, Olive green, French ultramarine, Black

- **Brushes**
 Angled brush
 Round brush, no. 20
 Coarse bristle brush
 Liner brush

- **Spray bottle**
 with water

The meadow flowers glow red like fire against the dark of the forest.

1 Using the angled brush and Transparent orange, paint a few large poppies in the foreground. Splatter Lemon yellow in the background using the round brush and spray water over it lightly. Paint Lemon yellow up to the edge of the forest.

2 Leave to dry. Draw in a bold line for the edge of the forest using the round brush and Lemon yellow. Spray on lots of water and then turn the picture so the paint spreads.

3 Leave to dry briefly. Mix Olive green with French ultramarine and, using the round brush, paint in a strong line with lots of paint for the forest edge. Spray with water then turn the picture so the dark trees take shape. A few lighter patches should remain here and there.

4 Paint the sky with French ultramarine, to form a hill. Splatter Transparent orange and Permanent red into the Lemon yellow meadow for more distant poppies using the bristle brush. Paint some areas of the meadow in May green and Olive green.

5 Intensify some poppies with Permanent red orange and some with Permanent red. Paint a dot in the centre of the flowers with May green and spray Black stamens with the bristle brush. Draw matching stems and grasses with the liner brush and Olive green.

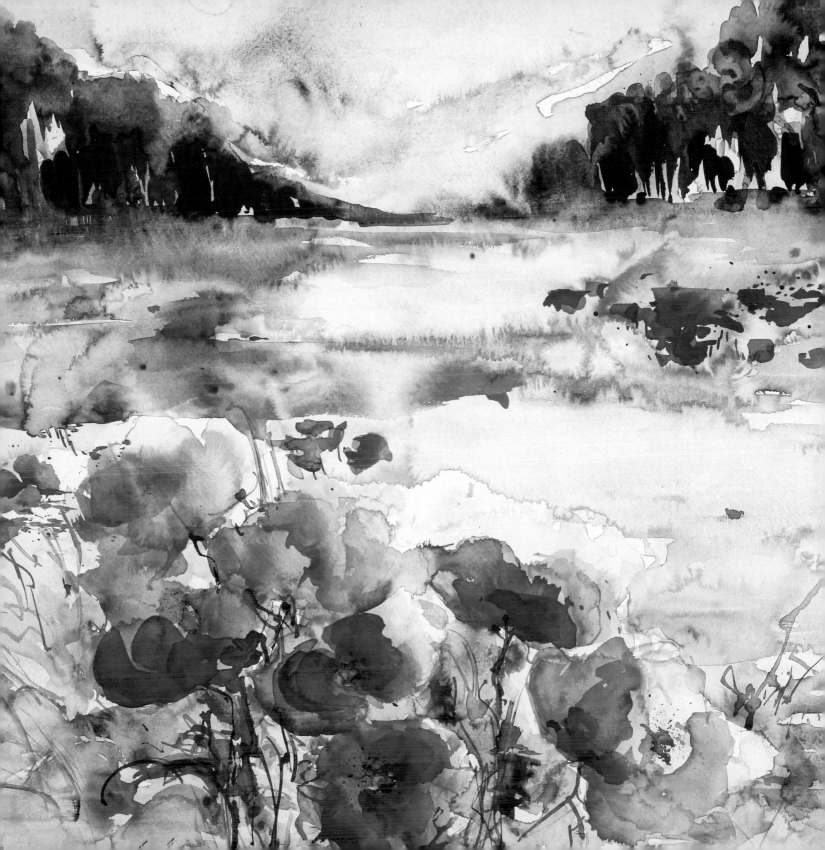

Summer
HARMONY

MATERIALS

- ↳ **Watercolour paper**
 Satin finish, 600gsm (300lb)

- ↳ **Watercolour paints**
 Lemon yellow, Pure yellow,
 Indian yellow, Mountain
 blue, French ultramarine,
 Rose madder, May green,
 Olive green

- ↳ **Brushes**
 Round brush, no. 20
 Angled brush
 Liner brush

- ↳ **Leaves**

- ↳ **Spray bottle**
 with water

*Combine summery flowers into
a beautiful bouquet.*

1 Paint the lilies using the angled brush and Lemon yellow. Draw the daisies using the liner brush and watery Mountain blue and then define them with a strong Mountain blue. Paint the background of the yellow lilies in Mountain blue. Spray water over and leave to dry.

2 Paint the centre of the daisies with Lemon yellow and a little Pure yellow. Shade the lilies, also using Pure yellow. Paint in the stamens using Indian yellow. Use the round brush and Mountain blue to splatter the rough shape of a delphinium. Draw the stem with the liner brush and Olive green. Lightly spray on water. Intensify the small flowers of the delphinium using Rose madder and French ultramarine.

3 Coat some leaves with Lemon yellow and May green and place onto the paper to match the flowers. Press the leaves firmly and immediately paint the background with Olive green to make the leaf shapes stand out sharply. Use the angled brush to draw in some rough stems in light blue and light green from the bottom up to the flowers. Intensify the background of the daisies and lilies with French ultramarine and Olive green.

4 Set shadows between the stems using Olive green.

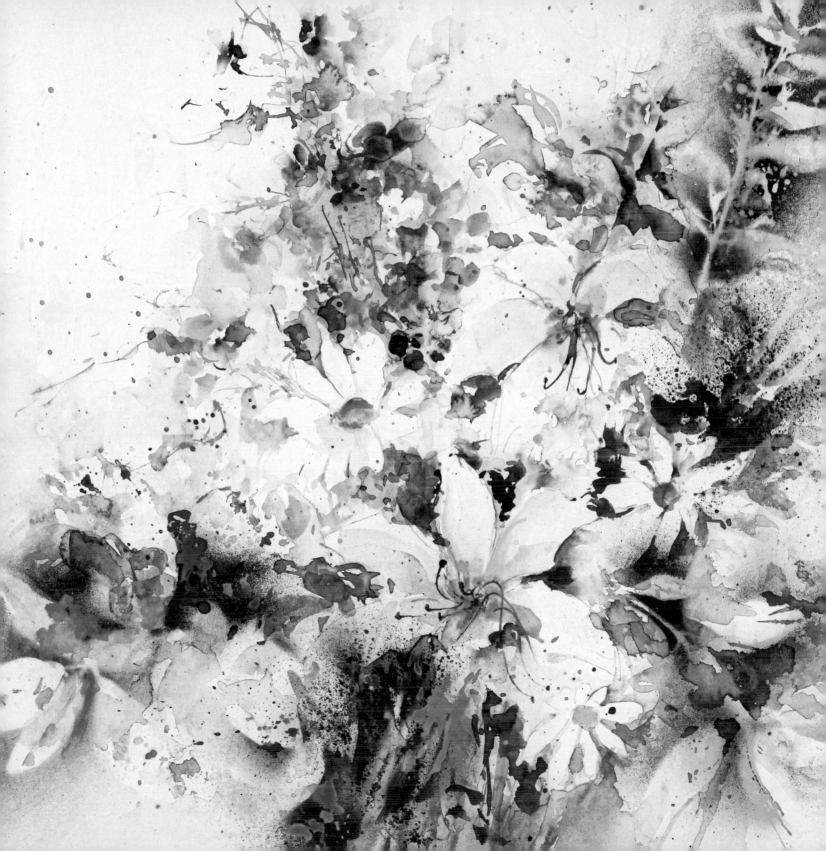

Down by the
RIVER

MATERIALS

⚸ **Watercolour paper**
Fine grain finish,
300gsm (140lb)

⚸ **Watercolour paints**
Lemon yellow, Pure yellow,
Indian yellow, May green, Olive
green, French ultramarine,
Ochre, Vandyke brown

⚸ **Brushes**
Round brush, no. 20
Coarse bristle brush
Angled brush

⚸ **Spray bottle**
with water

*The cloudy blue sky is reflected
in the river. Sunlight floods
through the old tree.*

1 Shape the trunk and the
branches with the angled
brush and Ochre.

2 For the leaves, use the bristle
brush to splatter on Lemon
yellow and, in places, Pure
yellow and Indian yellow.

3 Lightly spray on water so that
the colours can mix a little.
Leave to dry briefly, then
splatter some May green and
Olive green here and there
on the yellow area using the
bristle brush. Spray water
lightly over this area as well.

4 Intensify the bark and a few
of the branches using
Vandyke brown.

5 Paint in the water and the
shadows under the tree using
the round brush and French
ultramarine, and also a hint of
the sky using a diluted French
ultramarine. Let the blue sky
show through the leaf canopy
in places.

6 Paint in the meadow below
using May green and Olive
green. Let some Indian yellow,
Ochre and Vandyke brown
flow into it, replicating the
colours of the leaf canopy.

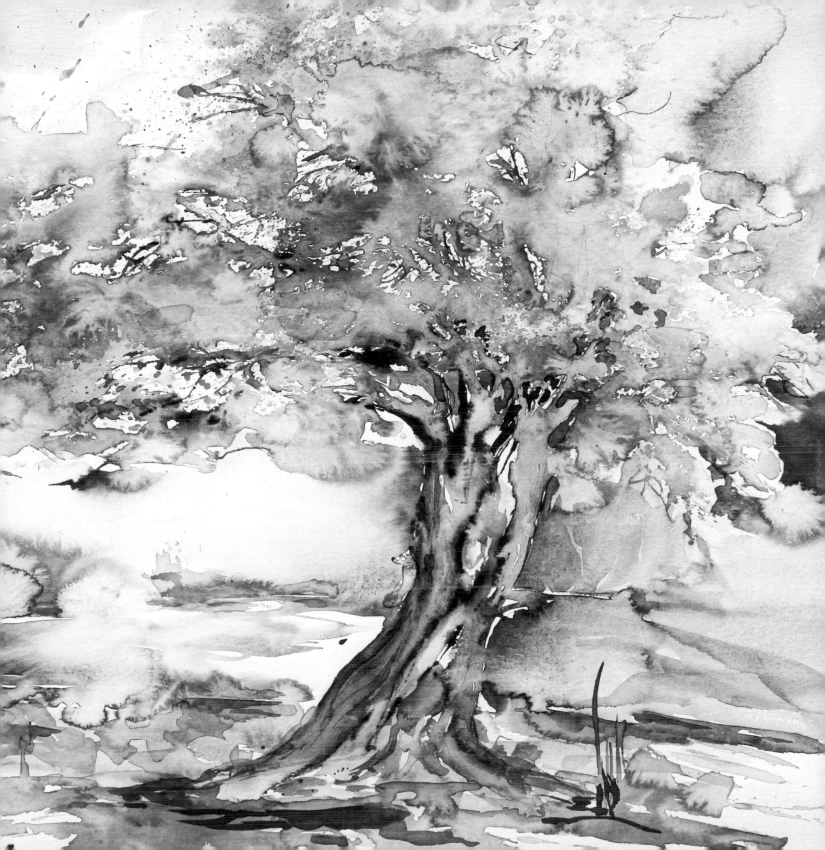

Daisy STARS

MATERIALS

↘ **Watercolour paper**
Fine grain finish,
300gsm (140lb)

↘ **Watercolour paints**
Lemon yellow, Pure yellow,
Transparent orange, Mountain
blue, French ultramarine, May
green, Olive green, Indigo

↘ **Brushes**
Round brush, no. 20
Angled brush
Liner brush

↘ **Spray bottle**
with water

The white blooming stars of daisies magically attract the eye as you stroll along.

1 Shape the centre of the largest daisy using the angled brush and Lemon yellow. Draw the outline of this first flower using the liner brush and some heavily diluted Mountain blue, then position the other daisies to complement the first one. Shape them in the same way using Mountain blue and Lemon yellow. This gives you looser petals without having to pay attention to pencil lines.

2 Now, use the angled brush to define the flowers using a strong Mountain blue and Lemon yellow. Carefully spray the outlines of the daisies with water so that the paint colours can spread.

3 Allow this first coat of colour to dry, then intensify the light blue areas using French ultramarine and Lemon yellow with Pure yellow. Apply Pure yellow and a little Transparent orange to the inside of the flowers and spray them lightly with a little water. Leave to dry.

4 Mix French ultramarine with Indigo and use it to create deep shadows under the petals. Mix May green with a little Olive green and let this colour partially flow into the yellow areas. Mix Olive green with a little French ultramarine and create some hints of grasses using the liner brush.

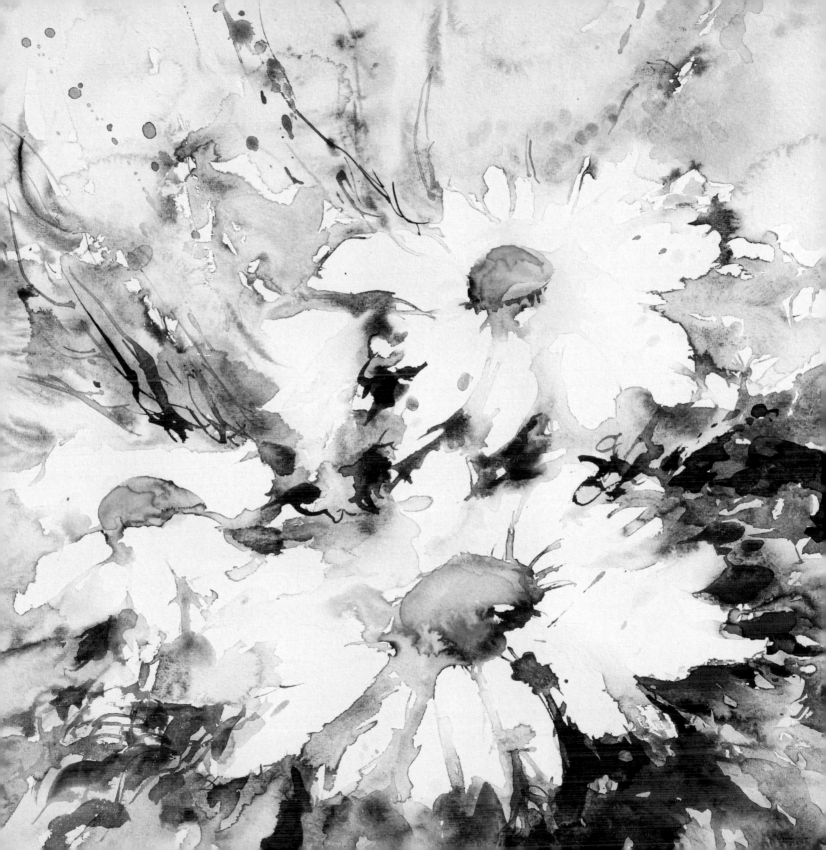

THE RIPENING

Grapes

MATERIALS

⚹ **Watercolour paper**
Fine grain finish,
300gsm (140lb)

⚹ **Watercolour paints**
Lemon yellow, Indian yellow,
May green, Olive green
yellowish, Olive green, French
ultramarine, Vandyke brown

⚹ **Brushes**
Round brush, no. 20
Angled brush
Liner brush

⚹ **Spray bottle**
with water

*All the fruits are still green
as the time of ripening is
upon them.*

1 Shape the grapes with the
round brush and Lemon
yellow. Splatter some Lemon
yellow in the background.

2 Draw the branch across the
picture using the angled brush
and a watery Vandyke brown.

3 Intensify the grapes using May
green and shape some larger
leaves using the round brush.
Leave one vine leaf light-
coloured and outline it with
French ultramarine. Create
hints of leaf veins using
the liner brush and some
Indian yellow.

4 Paint a few patches of Olive
green yellowish onto the
branch. Leave it to dry.

5 Define the leaves using French
ultramarine. Paint Olive green
yellowish and Olive green
and, in places, Indian yellow
onto the grapes. Lightly spray
water over it to allow the
colours to mix a little.

6 Finally, draw a few dry
twigs through the picture
using the liner brush and
Vandyke brown.

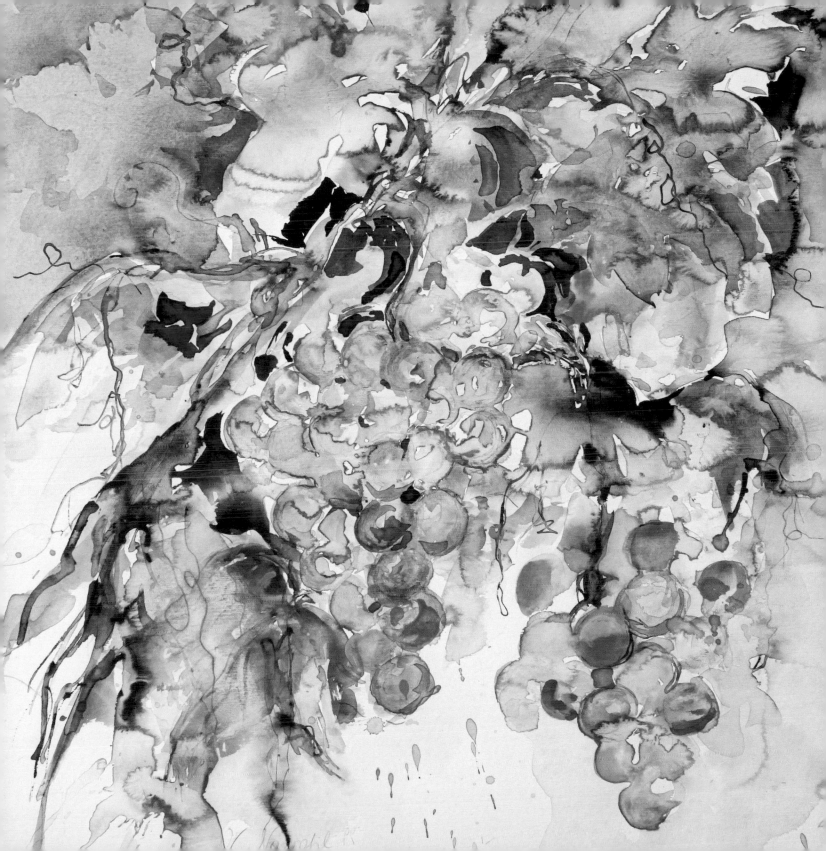

Cow Parsley
WITH POPPIES

MATERIALS

⤸ **Watercolour paper**
Satin finish, 300gsm (140lb)

⤸ **Watercolour paints**
Lemon yellow, Pure yellow, Transparent orange, Permanent red, May green, Olive green, French ultramarine, Black

⤸ **Brushes**
Round brush, no. 20
Angled brush
Liner brush

⤸ **Masking fluid**

⤸ **An old brush or a coarse sponge**

⤸ **Spray bottle**
with water

Filigree cow parsley and red poppies — a summer's day in the meadow.

1 Put some of the masking fluid in a small bowl and dilute it with a little water. Using either an old brush or a coarse sponge, dab on the cow parsley. Leave to dry.

2 Paint in the poppies using the angled brush and Transparent orange. Use the round brush to splatter Lemon yellow onto the background, as well as over the masked flower umbels. Carefully spray with water. Leave to dry.

3 Finish painting the poppies using Permanent red. Place a dab of May green in the centre of the flowers. Splatter some Pure yellow into the background. Dab on some buds in Olive green using

your finger, and draw in stems with the liner brush. Carefully spray water on them. Leave to dry again.

4 Mix May green with Olive green and paint leaves for the flower umbels using the angled brush. Add matching stems with the liner brush and Olive green. Mix Olive green with French ultramarine and paint over the masked white flowers and the shadows under the leaves with it. Use Black and the bristle brush to splatter the stamens into all the poppy blossoms.

5 Rub the dry masking fluid off the paper.

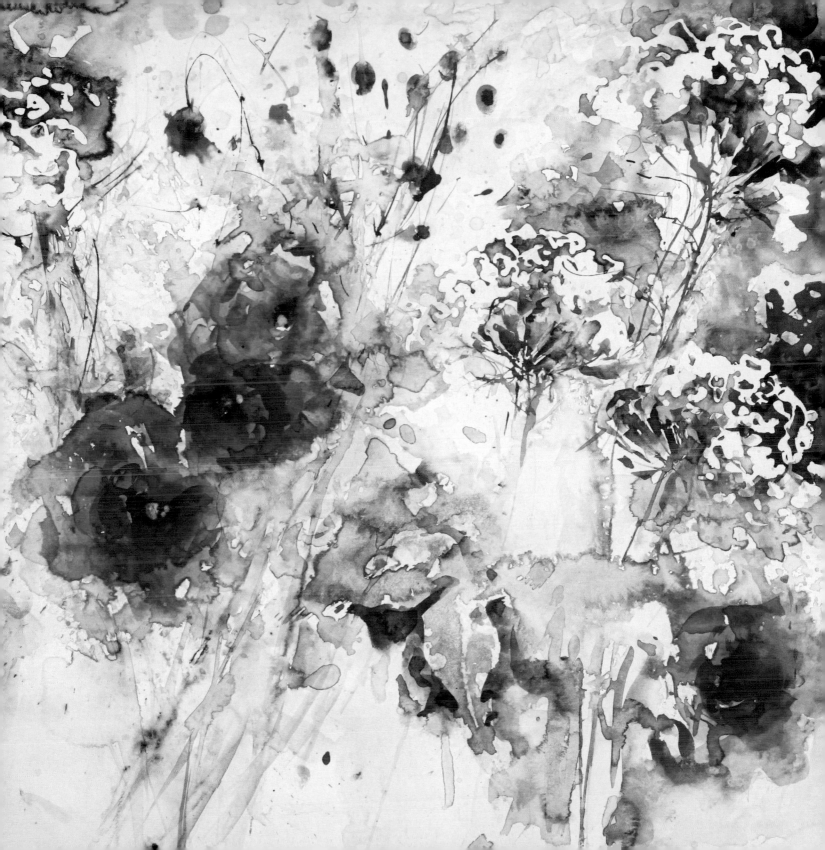

Dreamy
WATERLILIES

MATERIALS

- ↘ **Watercolour paper**
 Satin finish, 300gsm (140lb)

- ↘ **Watercolour paints**
 Lemon yellow, Pure yellow, Indian yellow, Brilliant blue violet, French ultramarine, Magenta, Olive green yellowish, Olive green

- ↘ **Brushes**
 Round brush, no. 20
 Angled brush
 Liner brush

- ↘ **Spray bottle**
 with water

Delicately coloured flowers float on the water, surrounded by fragile grass stems.

1 Shape the waterlilies with the liner brush and Lemon yellow. Splatter Lemon yellow into the background with the round brush and then spray some water on top. Allow to dry briefly. Accentuate the centre of the flowers with Pure yellow and splatter the stamens with the bristle brush and Indian yellow.

2 Paint some Magenta and Pure yellow into the background of the left flower, and paint Brilliant blue violet and French ultramarine into the background of the right flower. Spray water over them.

3 From left to right, paint under the waterlilies in Pure yellow, Brilliant blue violet and French ultramarine. Splatter Magenta into the dark areas using the round brush.

4 Let everything dry. Using Olive green yellowish, paint the stem of the bud and some hints of leaves. Draw grass stems through the picture with the liner brush. Shade some areas with Olive green.

5 After drying, lighten any areas in the water that are too dark with Lemon yellow, using the angled brush.

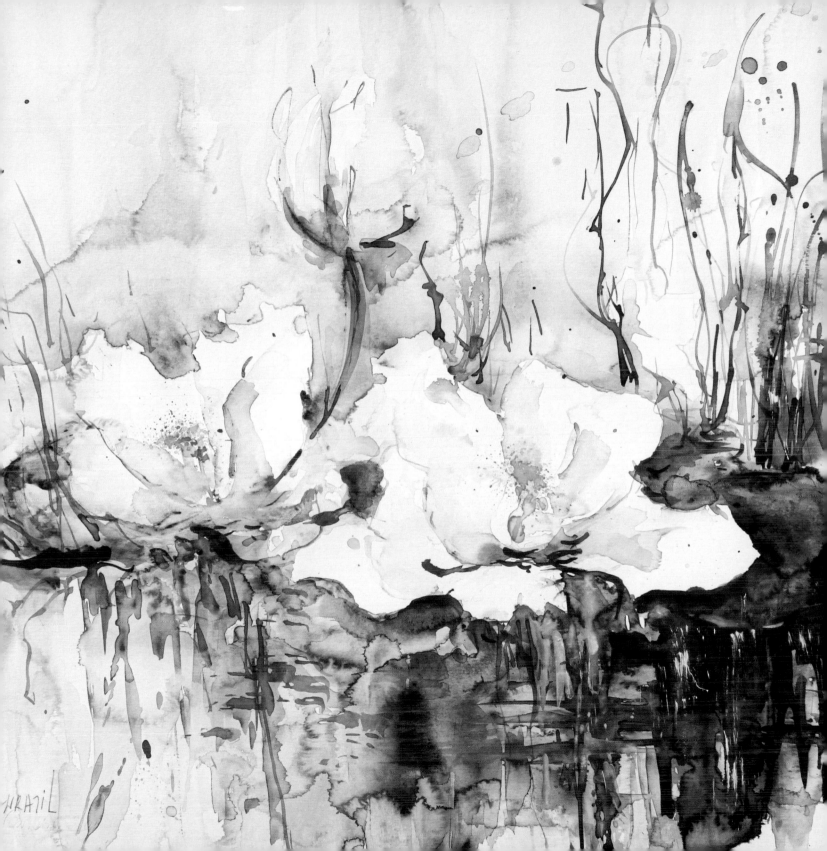

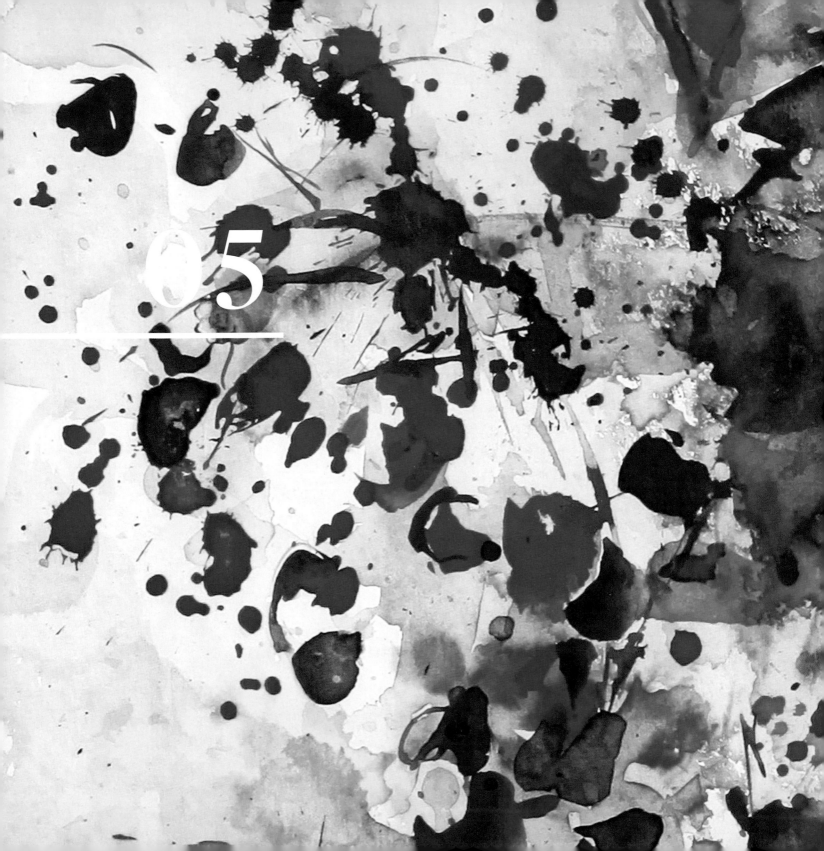

05

Autumn

Autumn also displays a wealth of colour especially in the world of trees, which are richly diverse. Be inspired by the nuances of the autumnal fruits and leaves. This season allows you to gather a copious harvest of inspiration. Varied branching patterns, especially in deciduous trees, become increasingly visible once some of the leaves have fallen. Try to emulate the shapes of nature and the brilliance of colour on your palette and to depict the natural shapes artistically, sometimes in an intensive and realistic way and sometimes only hinting at them.

NOVEMBER
Mood

MATERIALS

- ⚑ **Watercolour paper**
 Fine grain finish,
 300gsm (140lb)

- ⚑ **Watercolour paints**
 Pure yellow, Indian yellow,
 Transparent orange, French
 ultramarine, Sepia, Transparent
 brown, Indigo, Vandyke brown,
 Olive green yellowish

- ⚑ **Brushes**
 Round brush, no. 20
 Angled brush
 Liner brush
 Coarse bristle brush

- ⚑ **Spray bottle**
 with water

Another brief blaze of colour before the autumn wind blows the coloured splendour away.

1 The paints are kept wet in this picture, so that the colours blend into each other, leaving few hard outlines.

2 Paint the trees using the round brush and Sepia. Immediately splatter Pure yellow on the picture with the bristle brush, and partially over the tree trunks. Carefully spray water over it all so that the colours can mix a little.

3 Splatter Transparent orange into the leaf canopy in some places, and then spray water over it. Intensify the bark of the two tree trunks on the right using Transparent brown and Vandyke brown. Use the bristle brush to splatter Olive green yellowish here and there for the leaves. Use the round brush and French ultramarine to paint the sky, the shadows between the trees, and also along the path.

4 Mix French ultramarine with some Indigo and paint the dark areas at the end of the path. Leave some light-coloured suggestions of tree trunks. Paint the rest of the path in Indian yellow and then spray some water on it. Draw some more branches through the leaf canopy using the liner brush and Vandyke brown.

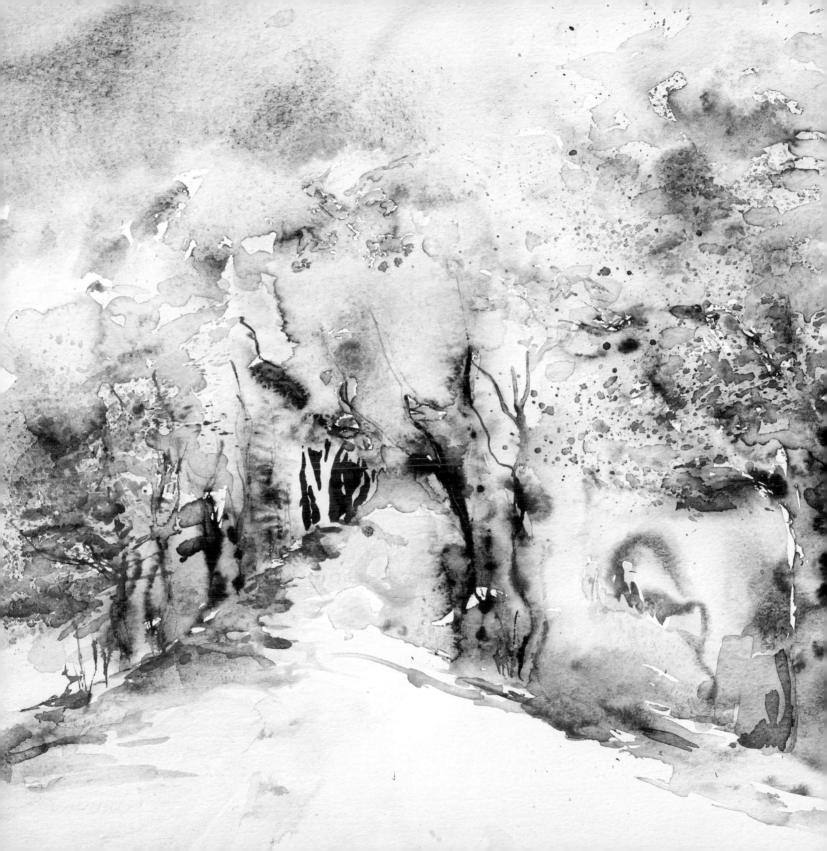

Flaming
FORESTS

MATERIALS

↳ **Watercolour paper**
Fine grain finish,
300gsm (140lb)

↳ **Watercolour paints**
Pure yellow, Indian yellow,
Transparent orange, Madder
lake deep, Ochre, Vandyke
brown, Transparent brown,
French ultramarine, Olive
green yellowish

↳ **Brushes**
Round brush, no. 20
Angled brush
Liner brush
Coarse bristle brush

↳ **Spray bottle**
with water

*After the first frost, fiery colours
explode in the trees.*

1 Paint in the tree trunks using
the round brush and Ochre.
For the leaves, splatter yellow
areas using the bristle brush
and Pure yellow, and then
spray a little water on them.
Some areas should remain
white. Allow to dry briefly.

2 Now, partially splatter Indian
yellow onto the light areas,
letting it dry briefly again.
Then splatter Transparent
orange, Olive green yellowish
and Madder lake deep — the
autumnal colours — into the
leaf canopy.

3 Draw some branches through
the picture using the Vandyke
brown and the liner brush.
Then shade the tree trunks
with Vandyke brown and
Transparent brown.

4 Paint the path with Pure
yellow and the shadows cast
by the trees with Transparent
brown and Vandyke brown.

5 Define the tree trunks boldly
using French ultramarine
on the right side, and with a
watery French ultramarine
on the left side. Use French
ultramarine for the sky as
well, so that it shines out.

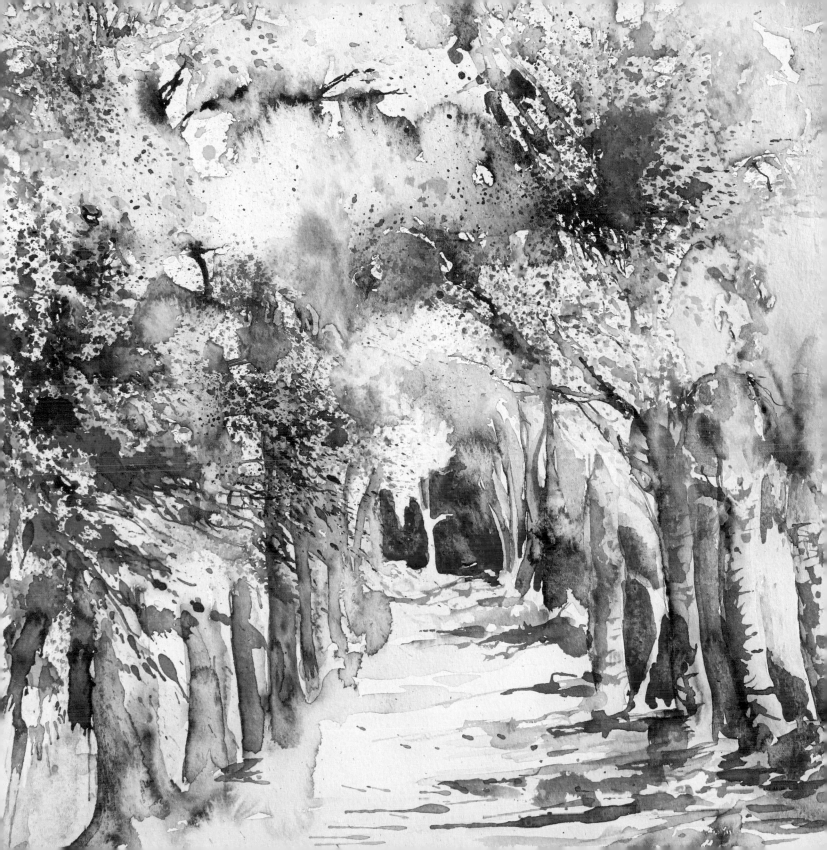

Colourful Autumn
BOUQUET

MATERIALS

- **Watercolour paper**
 Satin finish, 300gsm (140lb)

- **Watercolour paints**
 Pure yellow, Indian yellow,
 Transparent orange,
 Permanent orange, Permanent
 red, Madder lake deep,
 Magenta, Transparent brown,
 Vandyke brown

- **Brushes**
 Round brush, no. 20
 Angled brush
 Liner brush

- **Spray bottle**
 with water

Autumnal fruits, seed pods and berries and flowers influence the choice of the design.

1 Shape the outline of the vase using the angled brush and some watery Vandyke brown. Paint in the little Chinese lanterns using Pure yellow and then splatter Pure yellow into the background with the round brush.

2 Let it dry briefly. Dip your index finger in some Transparent orange and dab on the hints of seed pods. Repeat with the Permanent red and Magenta. Paint these colours into the Chinese lanterns as well, then lightly spray water all over the paper. Let it dry a little.

3 Draw matching coloured stems and the outlines of Chinese lanterns using the liner brush.

4 There are some white patches left here and there. You can highlight these as small flowers by accentuating the background in a darker colour (a mix of Permanent orange and Transparent brown).

5 Paint the vase in Indian yellow on the left side. Let Madder lake deep and Vandyke brown flow into it and carefully spray with water. The right side of the vase will remain light.

6 Use the angled brush with Transparent orange, Madder lake deep and Vandyke brown to form larger leaves here and there.

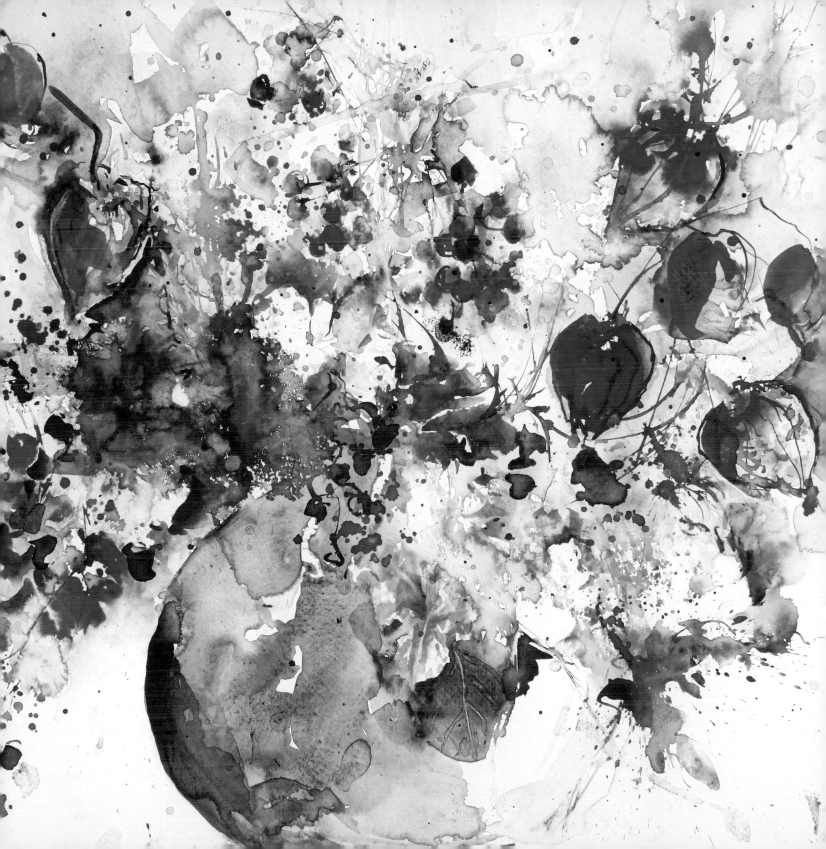

Fiery
CANOPY

MATERIALS

- **Watercolour paper**
 Fine grain finish,
 300gsm (140lb)

- **Watercolour paints**
 Lemon yellow, Pure yellow,
 Indian yellow, Transparent
 orange, Madder lake deep,
 Vandyke brown, French
 ultramarine, Olive green

- **Brushes**
 Round brush, no. 20
 Angled brush
 Liner brush
 Coarse bristle brush

- **Spray bottle**
 with water

The trees are adorned with a radiant splendour; they glow yellow, orange and fire-red. In some places, deep purple shimmers to violet.

1 Shape the two tree trunks using the angled brush and watery Vandyke brown. Splatter the leaf canopy using Lemon yellow and the bristle brush. Let it dry briefly, then splatter Pure yellow and Transparent orange over it. Carefully spray water on the painted surface so the colours can mix here and there.

2 After it has dried, spray Madder lake deep in places using the bristle brush. Draw a few branches through the leaves using the liner brush and Vandyke brown.

3 Allow to dry well. Paint a watery blue sky with the round brush and French ultramarine.

4 Paint the horizon and the water with French ultramarine. Leave a fine white stripe to separate the horizon and the water. Intensify the darkness strongly under the trees using French ultramarine.

5 Paint the meadow in Lemon yellow and then let some Indian yellow and Olive green flow into it.

6 Draw in some grasses in Olive green with the liner brush. Intensify the bark of the trees with Vandyke brown.

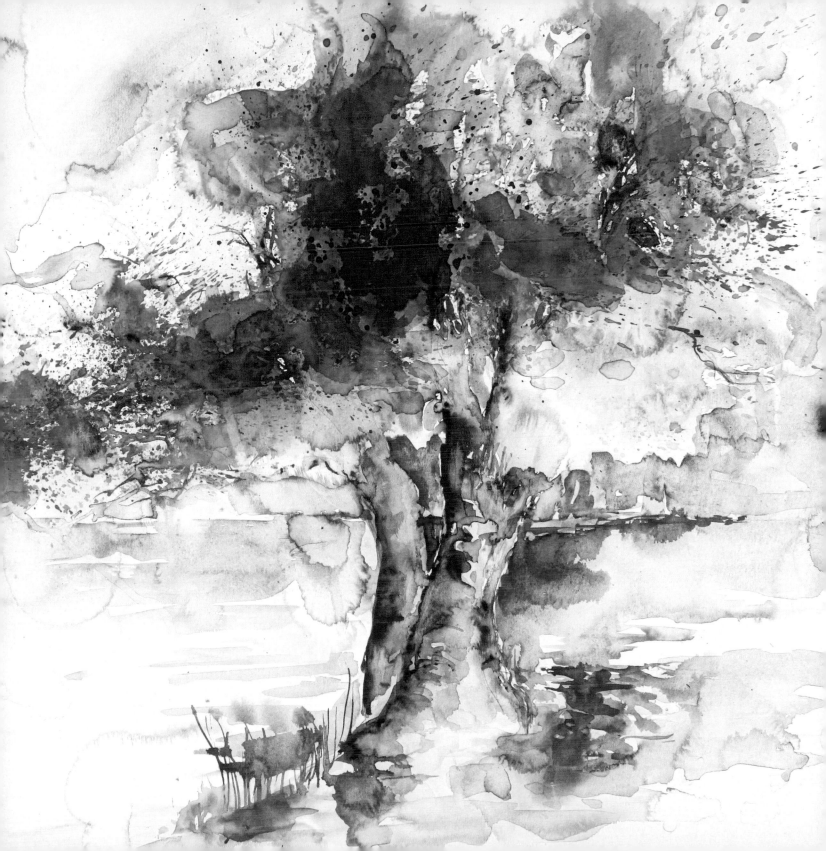

Autumnal
APPLE HARVEST

MATERIALS

- ↘ **Watercolour paper**
 Fine grain finish,
 300gsm (140lb)

- ↘ **Watercolour paints**
 Lemon yellow, Pure yellow,
 Indian yellow, Transparent
 orange, Permanent red orange,
 Quinacridone purple, French
 ultramarine, Cobalt turquoise,
 Olive green, Vandyke brown

- ↘ **Brushes**
 Round brush, no. 20
 Angled brush

- ↘ **Blunt pencil**

- ↘ **Spray bottle**
 with water

Lively accents in brightly shining colours — a pile of ripe apples in the fruit basket.

1 Spray your paint box well with water and dip the pencil in Vandyke brown.

2 Use it to shape the little crate and the base on which it stands. Paint the apples in Lemon yellow using the angled brush. Allow everything to dry briefly.

3 Now paint the next shade of the apples — so Pure yellow and Indian yellow in places, as well as Transparent orange and Permanent red orange here and there. Let Olive green flow into some of the apples.

4 On the left side, paint the background Pure yellow. Lightly spray water so that the colour can flow a little into the apples.

5 Highlight some parts of the crate using Indian yellow and Vandyke brown. Paint the shaded right side with Cobalt turquoise and spray water on it.

6 Shade some more of the darker patches with French ultramarine and Quinacridone purple.

7 Shape the leaves and stems with the angled brush and Olive green.

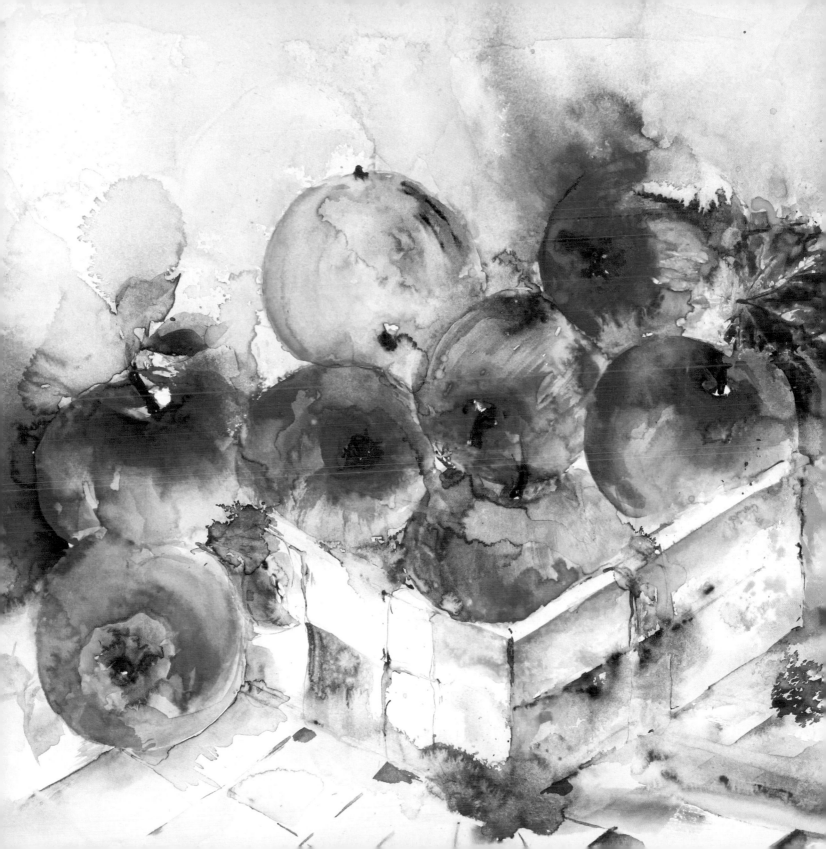

In the Warm
AUTUMN LIGHT

MATERIALS

- **Watercolour paper**
 Satin finish, 300gsm (140lb)

- **Watercolour paints**
 Jaune brilliant dark, Pure yellow, Indian yellow, Ochre, Olive green yellowish, Transparent brown, Vandyke brown

- **Brushes**
 Round brush, no. 20
 Angled brush
 Liner brush
 Coarse bristle brush

- **Cellophane paper**

- **Fern leaves**

- **Spray bottle**
 with water

Colours in unison — tone upon tone — conjure up a wildly romantic autumn forest.

1 Shape the two tree trunks using the angled brush and Ochre. Allow it to dry a little.

2 Use the bristle brush to splatter Pure yellow all over the picture, then Indian yellow in places. Spray water on top and rotate the picture so that the colours can mix a little.

3 Let it dry. Paint two ferns generously with Vandyke brown and lay these to the left and right of the tree trunks. Splatter Indian yellow, Ochre, Olive green yellowish and Transparent brown all around them. Spray everything with water and then place the cellophane paper over it.

4 Press the film onto the ferns and stroke over it firmly so that the colours mix underneath. Allow to dry. Remove the film and the ferns from the painting. Place the film, still with paint on it, lightly onto the upper half of the picture. Remove it again immediately so that it only leaves a light imprint.

5 Paint the tree trunks darker with Vandyke brown and then spray water over them.

6 Draw more grasses through the picture using Transparent brown and Jaune brilliant dark, and the liner brush.

The Forest
IS COLOURFUL

■ ■ ■ ■ ■

MATERIALS

☙ **Watercolour paper**
Satin finish, 600gsm (300lb)

☙ **Watercolour paints**
Lemon yellow, Pure yellow, Indian yellow, Transparent orange, Mountain blue, French ultramarine, Olive green yellowish, Olive green, Ochre, Vandyke brown

☙ **Brushes**
Round brush, no. 20
Angled brush
Liner brush
Coarse bristle brush

☙ **Spray bottle**
with water

An interplay of the vibrant colours on the earth and in the treetops.

1 Paint the tree trunks in Ochre with the round brush. Use the bristle brush to splatter Lemon yellow for the leaf canopy. Let it dry briefly, then splatter on Pure yellow and Indian yellow. Carefully spray water on top so that the colours can mix.

2 Allow to dry. Intensify the bark and branches of the trees using Vandyke brown on the angled brush. Splatter Olive green yellowish and Olive green into the leaves in places, as well as a little Transparent orange here and there. Again, carefully spray water on top.

3 When everything is dry, paint the sky in Mountain blue, and also draw a horizon line with Mountain blue. Allow to dry briefly. Paint French ultramarine into the empty spaces between the leaves and branches, and also into the darker shadows under the trees.

4 Paint the ground in Ochre and Indian yellow with the round brush and then paint some darker areas with Vandyke brown. Shape grasses using the liner brush and Olive green. Carefully spray water over them. Draw some thin branches through the leaf canopy using the liner brush and Vandyke brown.

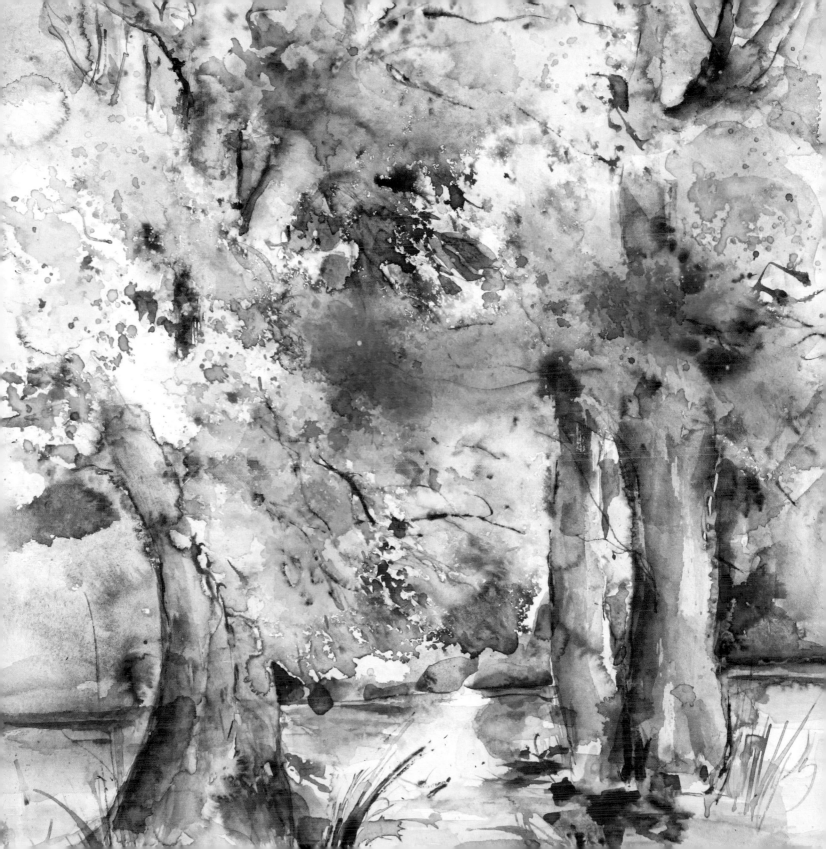

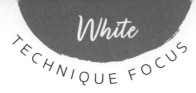
FADING
Summer

MATERIALS

⚑ **Watercolour paper**
Satin finish, 300gsm (140lb)

⚑ **Watercolour paints**
Pure yellow, Indian yellow,
Transparent orange, Brilliant
blue violet, Vandyke brown

⚑ **Brushes**
Round brush, no. 20
Angled brush
Liner brush

⚑ **Spray bottle**
with water

A fairy-tale bouquet of starry white flowers, autumn brown fern fronds, tendrils and twigs.

1 Shape the outlines of the daisies using the angled brush and Pure yellow and splatter Pure yellow onto the background. Carefully spray everything with water.

2 After everything has dried, paint the round vase using the round brush and Brilliant blue violet.

3 Using the angled brush and Brilliant blue violet, paint flower panicles and splatter Indian yellow here and there in the background. Spray these spots with water. Let it dry briefly. Highlight the white flowers some more, partially with Indian yellow and partially with Vandyke brown.

4 Paint an Indian yellow area into the vase. Using the angled brush and Vandyke brown, paint some matching stems and some hints of leaves onto the purple flower panicles.

5 Paint a dot in the middle of each daisy using Pure yellow. Splatter on some Transparent orange. Intensify the vase using Brilliant blue violet and spray water over it so the yellow and purple can mix to create a warm shade of brown. Draw a few grasses throughout using the liner brush and Vandyke brown. Shade the centre of the daisies a little more using Transparent orange.

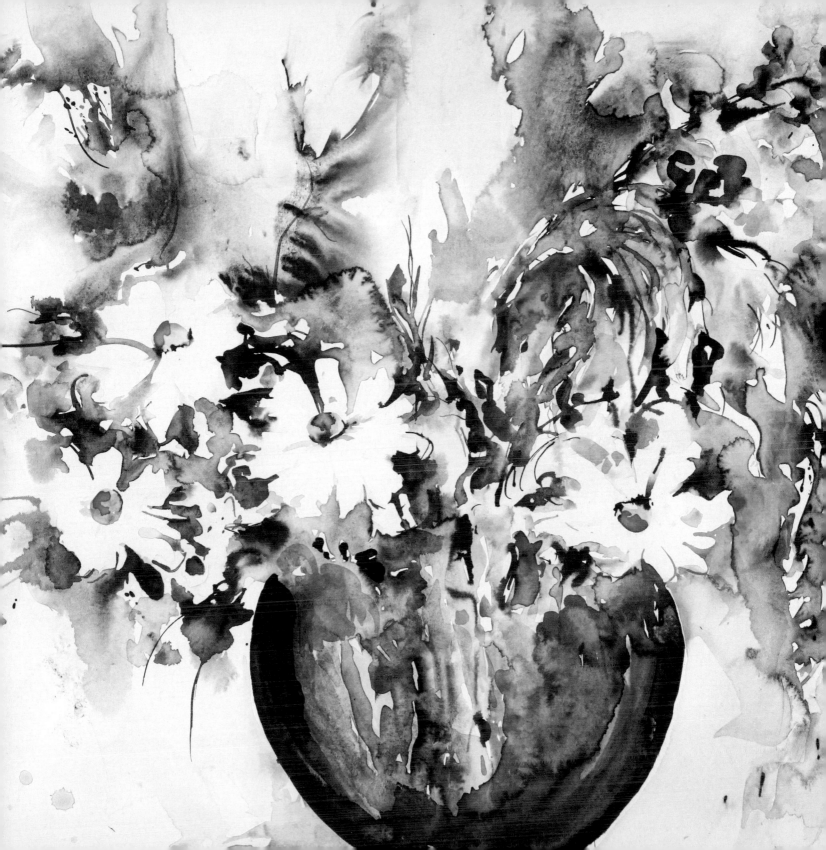

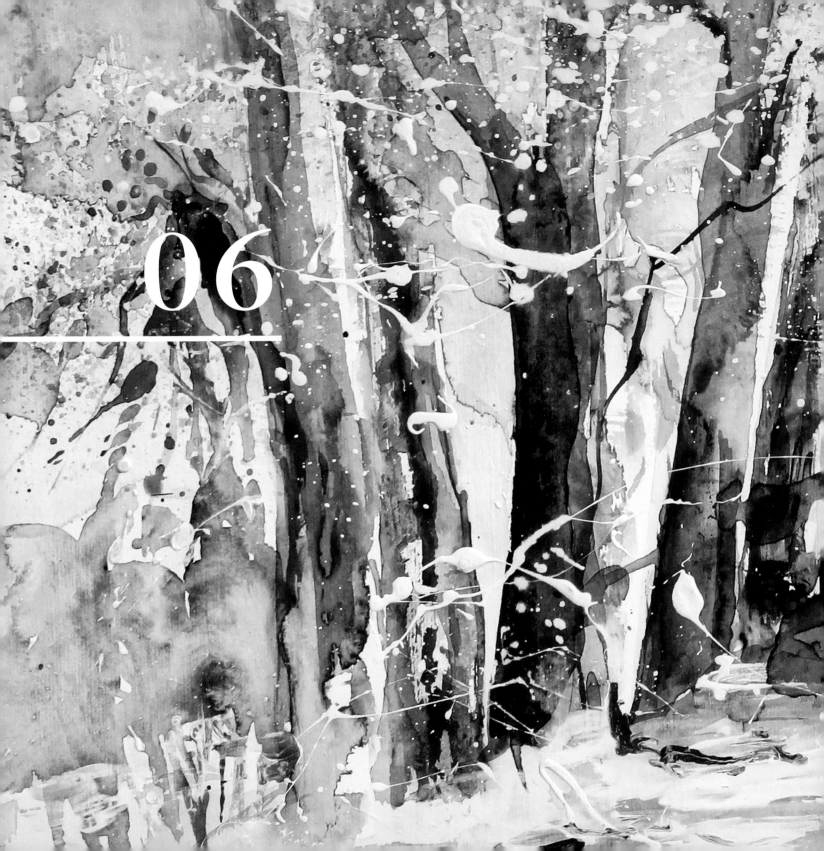

Winter

Icy cold winter days give you enough time to draw upon inspirations that have not yet been used and to make use of them in your paintings. Winter provides plenty of subjects, such as when taking a refreshing walk along a partially frozen stream, illuminated by the weak winter sun. Don't let inspirations that have an effect on you pass you by: seize upon them. And if you do not immediately make use of them, you should record your inspirations, like an archivist, for painting days to come.

A Bouquet of
CHRISTMAS ROSES

MATERIALS

⚹ **Watercolour paper**
Satin finish, 300gsm (140lb)

⚹ **Watercolour paints**
Lemon yellow, Indian yellow,
Mountain blue, French
ultramarine, Olive green
yellowish, Olive green

⚹ **Brushes**
Round brush, no. 20
Angled brush
Liner brush

⚹ **Spray bottle**
with water

The white of the Christmas roses shines clear and pure.

1 Paint the outlines of the white flowers using the liner brush and a watery Mountain blue. Intensify them with French ultramarine, splatter Lemon yellow into the background and then spray everything carefully with water.

2 The watery paints should run here and there into the white Christmas roses. Let the paint dry.

3 Use the round brush and French ultramarine to paint the background boldly, and spray some water on it.

4 Using Olive green yellowish, paint the stems and leaves for the flowers with the angled brush. Mix Olive green with a little French ultramarine and shade the light green areas with it. Draw some green and blue grasses throughout the picture with the liner brush.

5 Finally, use Indian yellow to suggest the stamens in the Christmas roses.

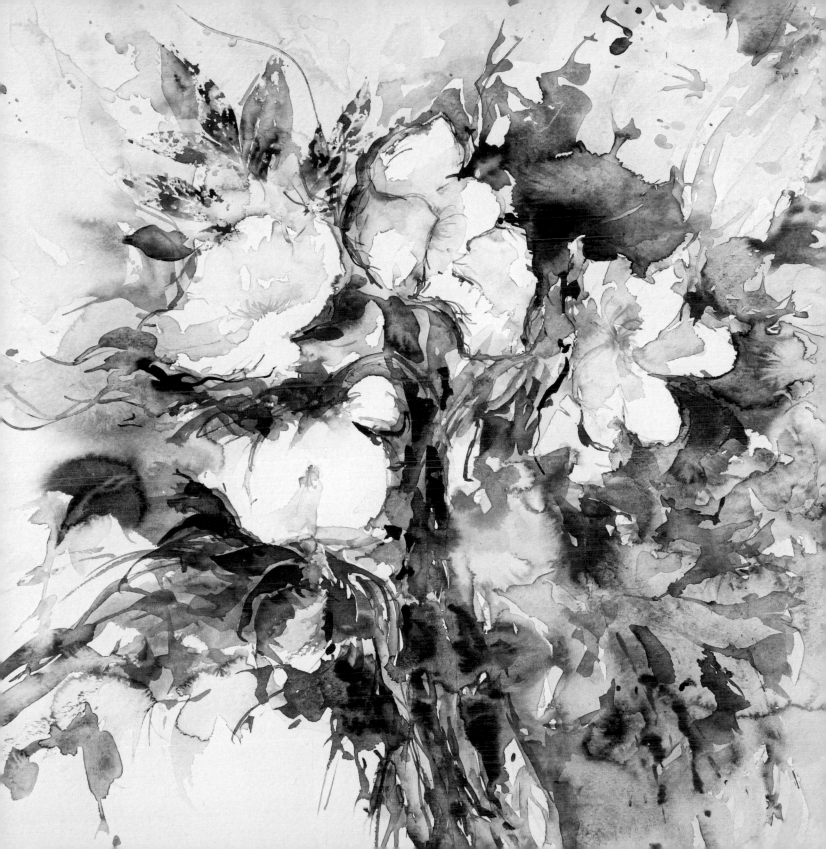

WINTER
by the Lake

MATERIALS

- ✘ **Watercolour paper**
 Satin finish, 300gsm (140lb)

- ✘ **Watercolour paints**
 Lemon yellow, Pure yellow,
 Mountain blue, French
 ultramarine, Indigo, Ochre,
 Vandyke brown, Transparent
 brown, Titanium opaque white

- ✘ **Brushes**
 Round brush, no. 20
 Angled brush
 Liner brush
 Coarse bristle brush

- ✘ **Spray bottle**
 with water

*Ice dances through the wintery
landscape; a moment of
stillness, to pause.*

1 Paint the tree trunks and the branches using the angled brush and Ochre. Paint the two houses in Mountain blue, leaving the roofs white.

2 Using the round brush, splatter Lemon yellow and Mountain blue for the background.

3 Intensify the trees, alternately using Vandyke brown and French ultramarine. Spray water over the paint so that the colours mix a little. Allow to dry briefly. Splatter Pure yellow over the light yellow spaces.

4 Shade the houses with Indigo and use French ultramarine to shape fir trees.

Paint in the lake with Mountain blue, shade the borders with Vandyke brown and, in places, with Transparent brown.

5 Paint shadows onto the lake using Indigo, Transparent brown and French ultramarine. Intensify the spaces between the trees with French ultramarine.

6 Mix Titanium opaque white with water into a thick paste and splatter snow onto the trees using the bristle brush. If an area has become too dark, apply some opaque white over the surface. Use the liner brush and Vandyke brown to draw branches through the still-wet, white splatters.

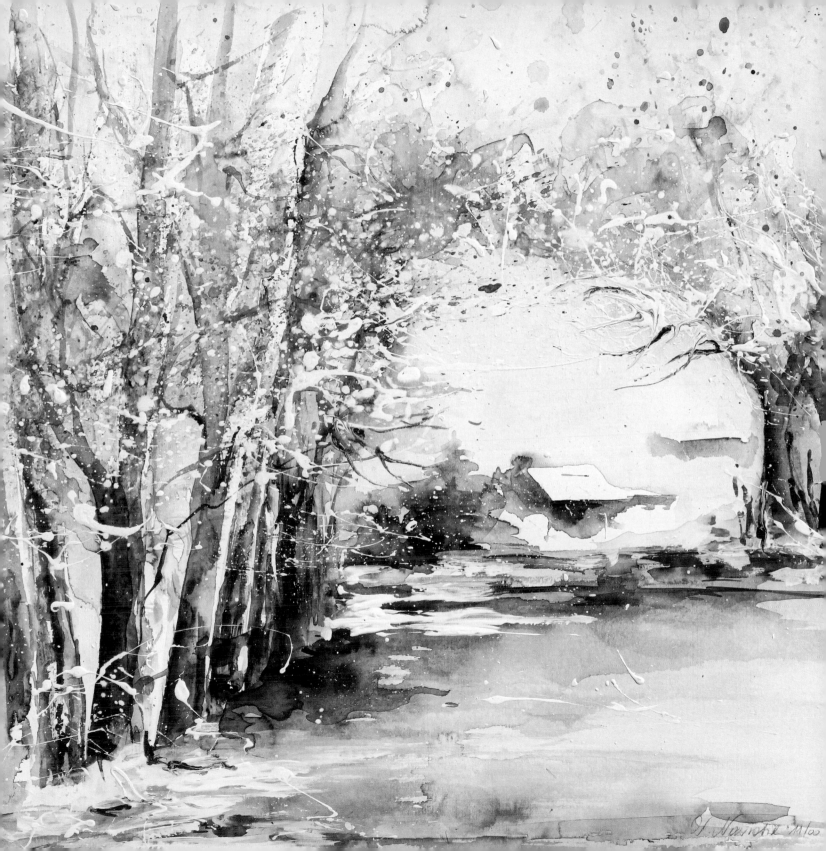

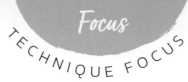

Rosy Red
AMARYLLIS

MATERIALS

↘ **Watercolour paper**
Fine grain finish,
300gsm (140lb)

↘ **Watercolour paints**
Lemon yellow, Transparent
orange, Rose madder,
Madder lake deep, Olive
green yellowish, Olive green,
French ultramarine

↘ **Brushes**
Round brush, no. 20
Angled brush
Liner brush

↘ **Spray bottle**
with water

Huge pink flowers warm the winter days, bringing colour to the eternal white of winter.

1 Paint the flowers of the amaryllis using the angled brush and Rose madder. Splatter Lemon yellow over the background and then spray everything with a fine mist of water.

2 Let it dry briefly. Paint in the stems and a few leaves using the angled brush and Olive green yellowish.

3 Shape the flowers again using Rose madder. Allow to dry briefly. Use Madder lake deep to intensify the centre of the amaryllis.

4 Draw the long stamens of the flower with Transparent orange and Lemon yellow, using the liner brush.

5 Paint darker areas into the stem and leaves using the angled brush and Olive green.

6 Splatter some French ultramarine here and there for contrast and finally spray a little water on top.

Tree in a
SNOWSTORM

- ↳ **Watercolour paper**
 Fine grain finish,
 300gsm (140lb)

- ↳ **Watercolour paints**
 Jaune brilliant dark, Indian
 yellow, Transparent orange,
 Ochre, Mountain blue, French
 ultramarine, Vandyke brown,
 Titanium opaque white

- ↳ **Brushes**
 Round brush, no. 20
 Angled brush
 Liner brush
 Coarse bristle brush

- ↳ **Spray bottle**
 with water

A snowstorm brings a glimpse of an enchanted winter forest.

1 Paint the tree trunk and branches using the angled brush and Ochre. Use the round brush to splatter Mountain blue and Jaune brilliant dark into places in the background. Spray a little water on top. However, leave a spot white for the setting sun.

2 Intensify the tree trunk and branches using Vandyke brown. Spray a little water onto these as well, so that the colour can flow into the background a little. When it is dry, paint the sun into the white area using Indian yellow, and add Transparent orange for the darker area.

3 Intensify the tree trunk again using Vandyke brown and paint in some darker areas using French ultramarine. Mix Titanium opaque white and some water into a thick paste and splatter the snow flurry onto the picture using the bristle brush.

4 Draw a few more branches through the wet white areas using the liner brush and Vandyke brown.

White Flowers
IN WINTER

MATERIALS

- **Watercolour paper**
 Fine grain finish,
 300gsm (140lb)

- **Watercolour paints**
 Lemon yellow, Pure yellow,
 Indian yellow, May green,
 Olive green, Mountain
 blue, French ultramarine,
 Transparent brown

- **Brushes**
 Round brush, no. 20
 Liner brush

- **Spray bottle**
 with water

Delicate Christmas roses, with their captivating grace, adorn a vase on the table.

1 Create the suggestion of a round vase, using the round brush and French ultramarine. Draw this colour into the vase body as well.

2 Using the liner brush and a watery Mountain blue, paint the first white flower and immediately define it using either French ultramarine or Lemon yellow. Carefully spray water over it so that no hard lines are visible. Repeat in this way, step-by-step, for all the other flowers.

3 Emphasize the centre of the flowers using Pure yellow and Indian yellow and then paint in some stamens in Transparent brown using the liner brush.

4 Paint the background of the flowers partially with May green and partially with Olive green. Intensify the blue areas using French ultramarine. Using the round brush and Olive green, apply a few coarse splatters to the green spaces, then lightly spray water over them.

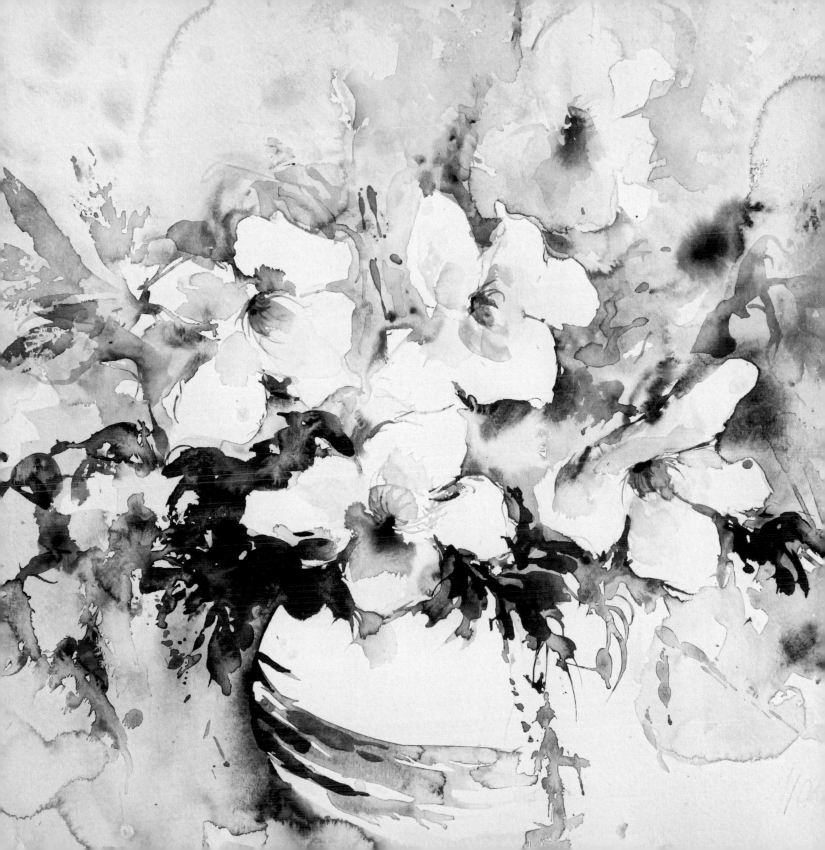

Pink
POINSETTIA

- ↘ **Watercolour paper**
 Satin finish, 300gsm (140lb)

- ↘ **Watercolour paints**
 Lemon yellow, May green,
 Olive green, French
 ultramarine, Titanium opaque
 white, Pure yellow, Transparent
 orange, Rose madder

- ↘ **Brushes**
 Round brush, no. 20
 Angled brush

- ↘ **Leaves**
 from a poinsettia

- ↘ **Spray bottle**
 with water

*A delicate burst of colour in the
shape of a star for those darker
winter days.*

1 Paint a poinsettia leaf with
May green and Olive green
and press it briefly onto the
paper. Remove it, paint the
leaf again with this mixture
and press it next to the first
print. If you mix Olive green
with French ultramarine,
Lemon yellow or May green,
you will get different shades
of green for the leaves. Now
and again, you can also
paint in a pink leaf with Rose
madder. Continue in this way
until you have created the
diagonal design.

2 Spray the whole surface
lightly with water so that the
leaves do not have hard edges
and they blend together softly
here and there.

3 Allow to dry. Now paint some
leaves with White and place
these in a star-shape on the
green and pink areas. Place a
few dabs of Pure yellow and
Transparent orange in the
centre of the poinsettia, using
the angled brush.

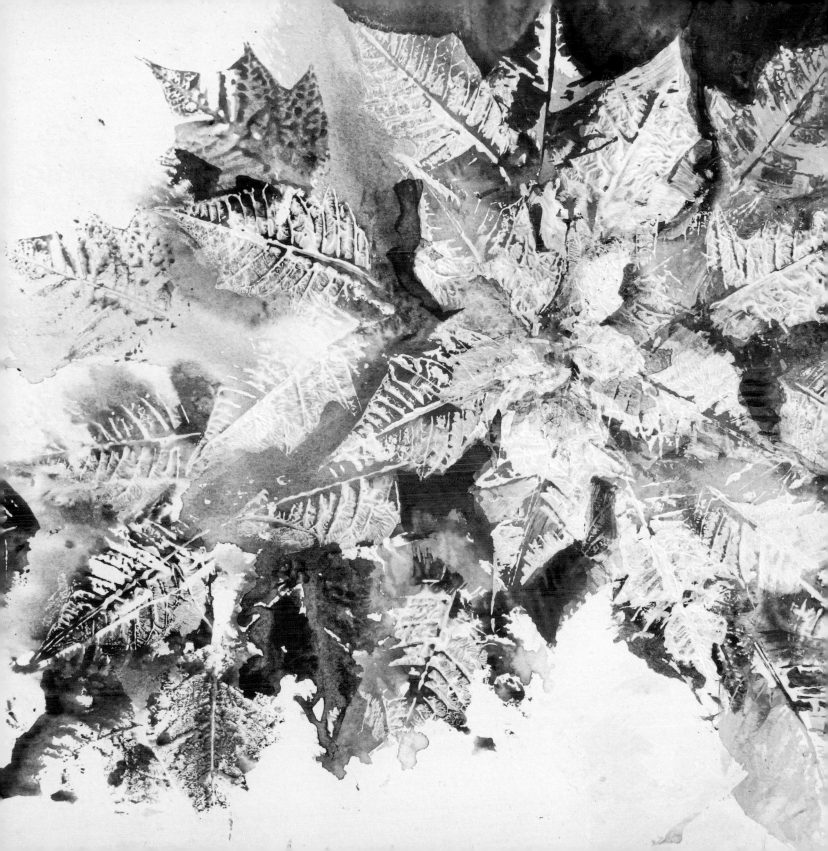

Gallery and final words

With the following few pictures, I would like to supplement and build upon the variations in inspiration for individual seasons. Reading, contemplating, being inspired, trying it out for yourself and achieving personal perfection should be the steps you follow when practising the visual arts.

Be bold and don't be afraid to be generous with the water bottle. Both the paper and the paints give you the leeway to transform what may be a 'runny' picture into a work of art.

When painting in watercolour, remember to start with soft, light colours and let the colour gradation find its own way. After a little drying time, outlines of flowers or trees will emerge, which can then be emphasized using more vibrant colour elements such as grasses or dabs of colour.

Combine different flowers with trees or with other flowers. To do this, look at nature, which is where you will find the best template.

Striving for recognition to the point that others express pleasure in your achievements can be another goal. With the joy of recognition, further success will come, and this will also give you inspiration for the future.

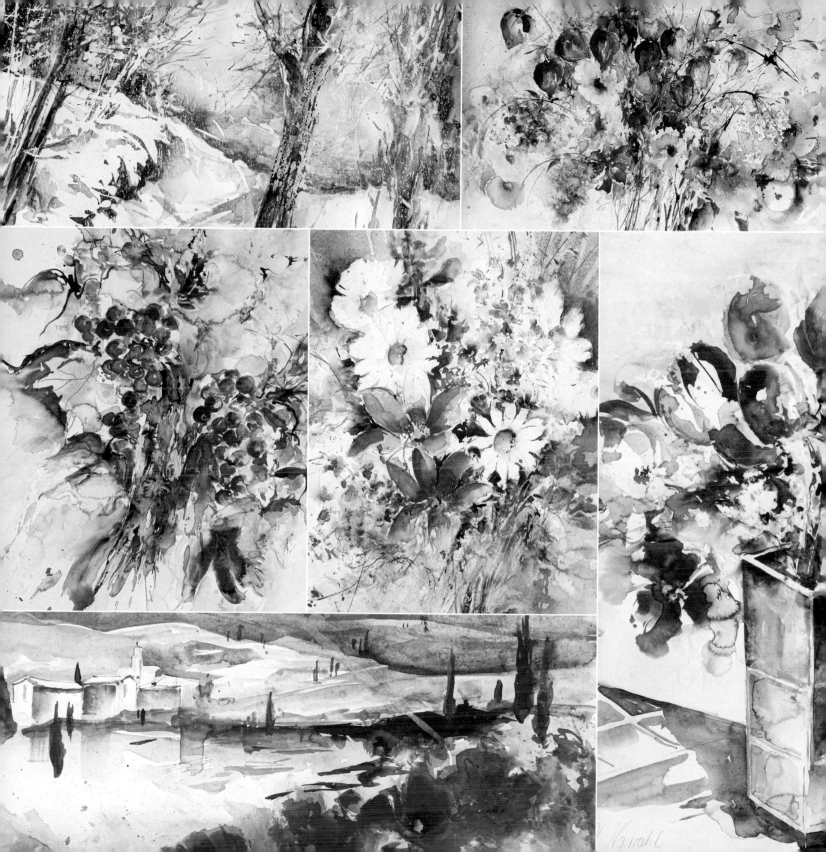

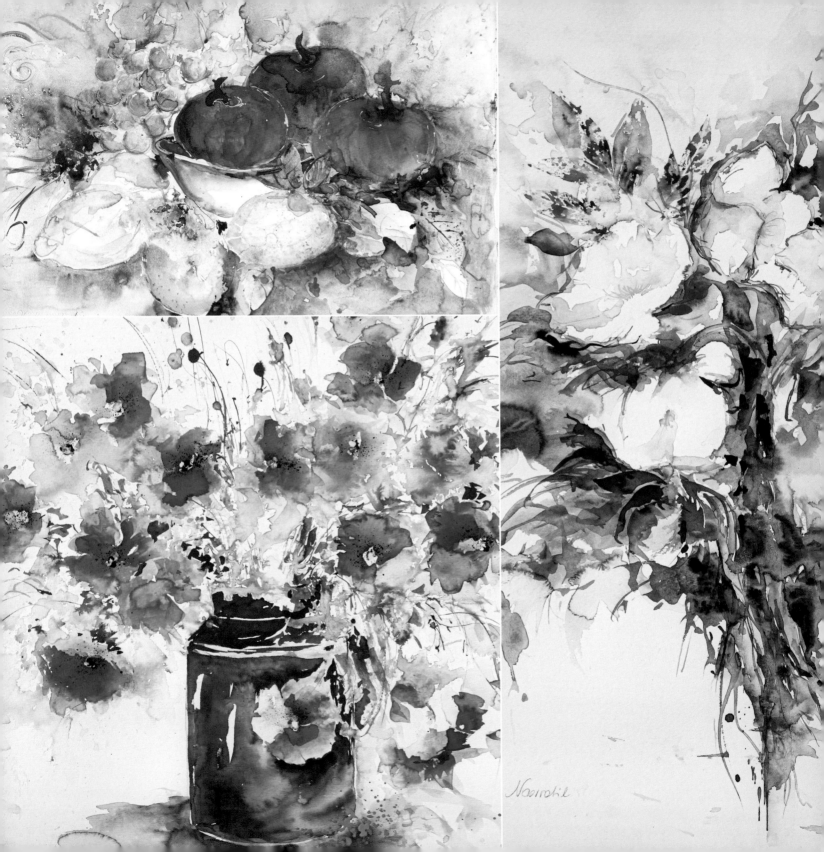

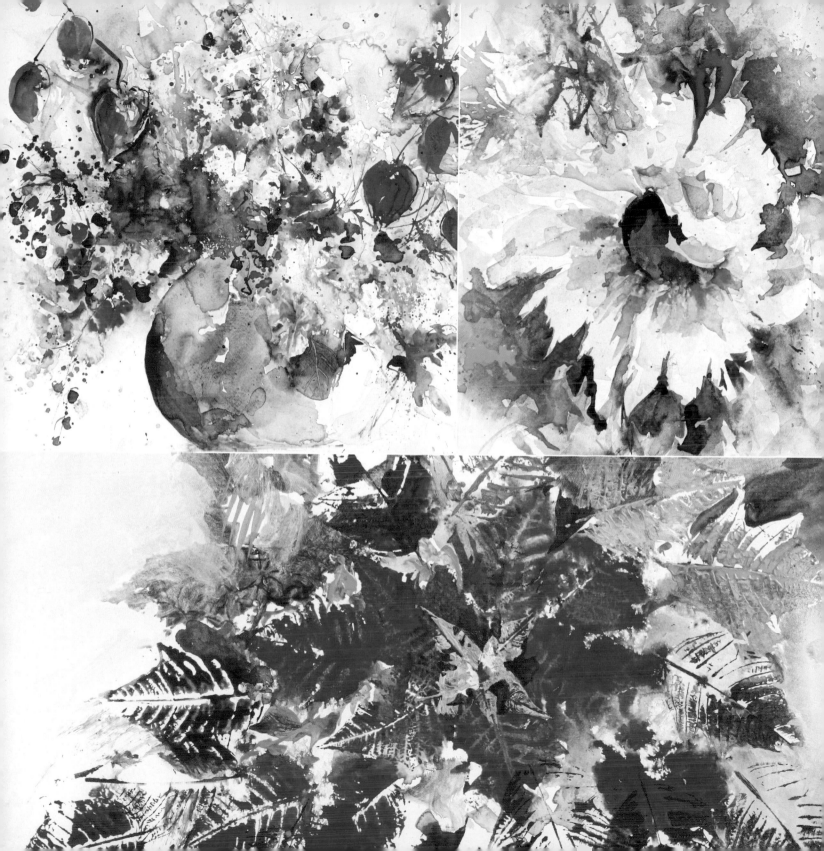

About the author

Waltraud Nawratil was born in Styria, Austria in 1947. Since the 1980s, she has lived with her family – her husband and children – in Schönering. Her garden serves as an inexhaustible source of inspiration for her painting work. From her small studio, she looks out of the window directly into nature.

It was in 1995 that Waltraud started painting at a local primary school, where, searching for new challenges, she attended a watercolour painting course. She worked mainly with flower designs due to the bold, intense colours, but soon went on to include more designs from the entire palette of nature, such as tree-lined avenues and floral landscapes.

Over time, she attended further painting courses to develop her technique and experiment with different media and materials. It turned out that Waltraud also found acrylic painting particularly interesting, since this technique offers the possibility of applying several coats to the painting, and of creating lively textures with real natural materials, such as sand or leaves.

One of her teachers was Mrs Inge Peischl, who is still her teacher to this day. She has always accompanied Waltraud on her path and showed her the joy of painting. This feeling is what Waltraud wants to reflect in her paintings and also help the viewer to feel. One of her daughters expressed this perfectly with the words: 'Mum, looking at your pictures makes me happy.'

Acknowledgements

To me, the joy of capturing the beautiful diversity of nature in vibrant colours using different techniques – and being able to pass on this enthusiasm – is the most important thing about my painting.

So I would like to thank you, the readers of my books, as well as those people who are interested in and who feel inspired by my works and who dedicate themselves to the art of painting.

I would like to express my gratitude to Edition Michael Fischer and its staff for a harmonious working relationship in the joint conception, realization and printing of my specialist books.

And, above all, I thank my family, who in every moment of my work provide me with understanding, support and confidence.

THANKS

Copyright